Turner

1775-1851

Page 4: *Self-Portrait*, c. 1798
oil on canvas, 74.5 x 58.5 cm
Turner Bequest, Tate Britain, London

ISBN 1-84013-745-2

CREDITS
Tate Britain
British Museum, London
Royal Academy of Arts, London
Victoria and Albert Museum, London
Fitzwilliam Museum, Cambridge, UK
Lady Lever Art Gallery, Port Sunlight, UK
University of Reading, Reading, UK
National Portrait Gallery, UK
Cecil Higgins Art Gallery, Bedford
Indianapolis Museum of Art

Published in 2004 by Grange Books
an imprint of Grange Books Plc
The Grange Kingsnorth Industrial Estate
Hoo, nr Rochester, Kent ME3 9ND
www.grangebooks.co.uk

Printed in China

Foreword

"J.M.W. Turner is the only man who has ever given an entire transcript of the whole system of nature, and is, in this point of view, the only perfect landscape painter whom the world has ever seen... We have had, living with us, and painting for us, the greatest painter of all time; a man with whose supremacy of power no intellect of past ages can be put in comparison for a moment."

John Ruskin, 1843

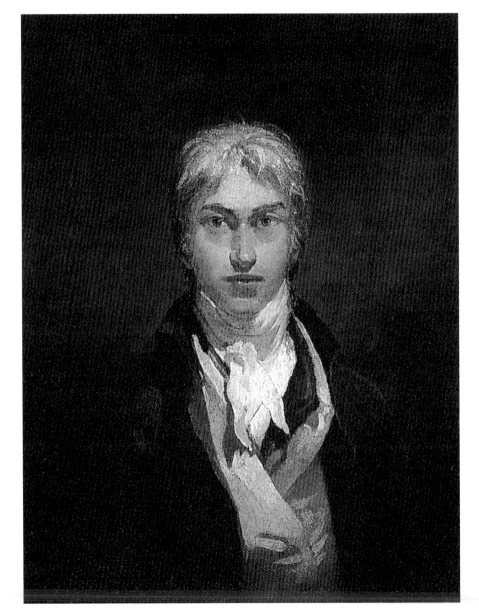

Biography

1775 Birth of Joseph Mallord William Turner in London on 23 April.

1787 Makes first signed and dated watercolours.

1789 Probably begins studying with Thomas Malton, Jr. and also admitted as student to Royal Academy Schools.

1790 Exhibits first work at the Royal Academy.

1791 Tours the West Country.

1792 Tours south and central Wales.

1793 Awarded the 'Greater Silver Pallet' for landscape drawing by the Royal Society of Arts.

1794 Tours Midlands and north Wales.

1795 Tours southern England and south Wales.

1796 Exhibits first oil painting at the Royal Academy.

1797 Tours north of England and Lake District.

1798 Tours north Wales.

1799 Elected an Associate Royal Academician. Visits West Country, Lancashire and north Wales.

1801 Tours Scotland.

1802 Elected Royal Academician. Tours Switzerland.

1804 Death of mother after a long illness.

1805 Holds first exhibition in own gallery in London.

1807 Elected Royal Academy Professor of Perspective.

1808 Visits Cheshire and Wales. Probably pays first visit to Farnley Hall, home of Walter Fawkes.

1811 Delivers first course of perspective lectures at the Royal Academy. Tours West Country for material for the 'Southern Coast' series.

1812 First quotation from his own poem, 'Fallacies of Hope', in the Royal Academy catalogue.

1813 Completes Sandycombe Lodge in Twickenham. Revisits West Country.

1814 Again tours West Country.

1815 Tours Yorkshire.

1816 Tours Yorkshire to gain material for the 'Richmondshire' series.

1817 Tours Belgium, Germany and Holland.

1818 Visits Edinburgh.

1819 Walter Fawkes exhibits over sixty Turner watercolours in his London residence. Pays first visit to Italy, stays in Venice, Florence, Rome and Naples.

1821 Visits Paris and tours northern France.

1822 Visits Edinburgh for State Visit of King George IV.

1824 Tours south-east England, also the Meuse and Moselle rivers.

1825 Tours Holland, Germany and Belgium. Death of Walter Fawkes.

1826 Tours Germany, Brittany and the Loire.

1827 Stays at East Cowes castle, the home of the architect John Nash. Autumn, starts visiting Petworth regularly.

1828 Delivers last lectures as Royal Academy Professor of Perspective. Visits Italy a second time, stays principally in Rome.

1829 Exhibits seventy-nine 'England and Wales' series watercolours in London. Visits Paris, Normandy and Brittany. Death of father. Draws up first draft of will.

1830 Tours Midlands. Exhibits a watercolour for the last time at the Royal Academy.

1831 Tours Scotland. Revises will.

1832 Visits Paris, probably meets Delacroix.

1833 Exhibits 66 'England and Wales' watercolours in London. Visits Vienna and Venice.

1835 Tours Denmark, Prussia, Saxony, Bohemia, the Rhineland and Holland.

1836 Tours France, Switzerland and the Val d'Aosta.

1837 Death of Lord Egremont. Resigns as Royal Academy Professor of Perspective.

1839 Tours the Meuse and Moselle rivers.

1840 Meets John Ruskin for the first time. Visits Venice.

1841 Tours Switzerland, and does so again in following three summers.

1845 Acts as temporary President of Royal Academy. Tours northern France in May; in the autumn Dieppe and Picardy, his last tour.

1846 Moves to Chelsea around this time.

1848-49 Growing infirmity. Revises will.

1850 Exhibits for the last time at the Royal Academy.

1851 Dies 19 December in Chelsea, London.

F rom darkness to light: perhaps no painter in the history of western art evolved over a greater visual span than Turner. If we compare one of his earliest exhibited masterworks, such as the fairly low-keyed *St Anselm's Chapel, with part of Thomas-à-Becket's crown, Canterbury Cathedral* of 1794, with a vividly bright picture dating from the 1840s, such as *The Falls of the Clyde*, it seems hard to credit that the two images stemmed from the same hand, so vastly do they differ in appearance. Yet this apparent disjunction can easily obscure the profound continuity that underpins Turner's art, just as the dazzling colour, high tonality and loose forms of the late images can lead to the belief that the painter shared the aims of the French Impressionists or even that he wanted to be some kind of abstractionist, both of which notions are untrue.

Folly Bridge and Bacon's Tower, Oxford

1787
pen and ink with watercolour, 30.8 x 43.2 cm
Turner Bequest, Tate Britain, London
The work is a transcription of an image made for The Oxford
Almanack by Michael Angelo Rooker

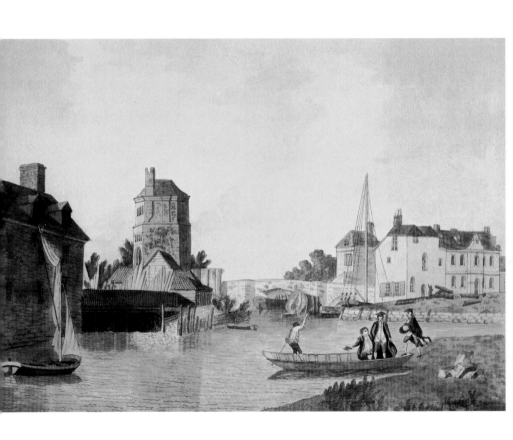

Instead, that continuity demonstrates how single-mindedly Turner pursued his early goals, and how magnificently he finally attained them. To trace those aims and their achievement by means of a selective number of works, as well as briefly to recount the artist's life, is the underlying purpose of this book.

Joseph Mallord William Turner was born at 21 Maiden Lane, Covent Garden, London, sometime in late April or early May 1775. (The artist himself liked to claim that he was born on 23 April which is both our national day, St George's Day, and William Shakespeare's birthday, although no verification of that claim has ever been found.) His father, William, was a wig-maker who had taken to cutting hair after wigs began to go out of fashion in the 1770s. We know little about Turner's mother, Mary (born Marshall), other than that she was mentally

Harewood House from the South-East

1798
pencil and watercolour, 47.4 x 64.5 cm
Trustees of The Harewood House Trust

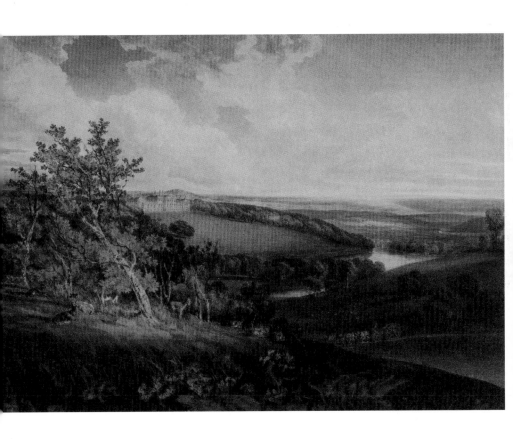

unbalanced, and that her instability was exacerbated by the fatal illness of Turner's younger sister, who died in 1786. Because of the stresses put upon the family by these afflictions, in 1785 Turner was sent to stay with an uncle in Brentford, a small market town to the west of London. It was here he first went to school. Brentford was the county town of Middlesex, and had a long history of political radicalism, which may have surfaced much later in Turner's work. But more importantly, the surroundings of the town – the rural stretches of the Thames downriver to Chelsea, and the countryside upriver to Windsor and beyond – must have struck the boy as Arcadian (especially after the squalid surroundings of Covent Garden), and done much to form his later visions of an ideal world.

The Archbishop's Palace, Lambeth

RA 1790
watercolour, 26.3 x 37.8 cm
Indianapolis Museum of Art, Indianapolis
Indiana, U.S.A

By 1786 Turner was attending school in Margate, a small holiday resort on the Thames estuary far to the east of London. Some drawings from this stay have survived and they are remarkably precocious, especially in their grasp of the rudiments of perspective. His formal schooling apparently completed, by the late 1780s Turner was back in London and working under various architects or architectural topographers. They included Thomas Malton, Jr, whose influence on his work is discernible around this time.

After Turner had spent a term as a probationer at the Royal Academy Schools, on 11 December 1789 the first President of the Royal Academy, Sir Joshua Reynolds (1723-92), personally interviewed and admitted him to the institution. The Royal Academy Schools was then the only regular art training

Interior of King John's Palace, Eltham

c. 1791
watercolour, 33.2 x 27 cm
Yale Center for British Art, New Haven, Conn

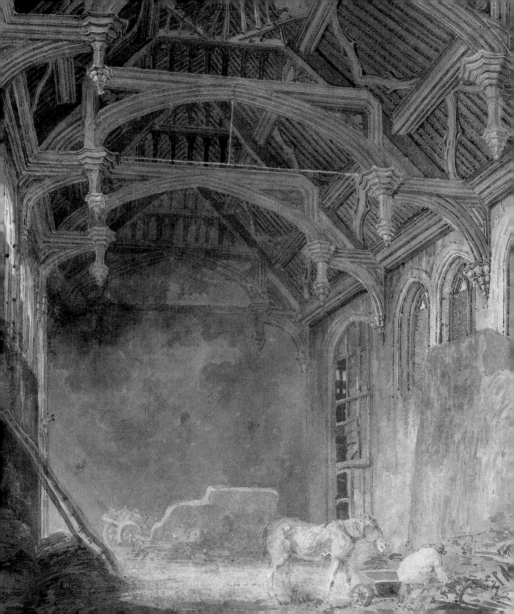

establishment in Britain. Painting was not taught there – it would only appear on the curriculum in 1816 – and students merely learned to draw, initially from plaster casts of antique statuary and then, when deemed good enough, from the nude. It took the youth about two and a half years to make the move. Amongst the Visitors or teachers in the life class were History painters such as James Barry RA and Henry Fuseli RA whose lofty artistic aspirations would soon rub off on the young Turner.

Naturally, as Turner lived in the days before student grants, he had to earn his keep from the beginning. In 1790 he exhibited in a Royal Academy Exhibition for the first time, and with a few exceptions he went on participating in those annual displays of contemporary art until 1850. In that era the Royal Academy only mounted one exhibition every year, and

The Pantheon, the Morning after the Fire

RA 1792
watercolour, 39.5 x 51.5 cm
Turner Bequest, Tate Britain, London

17

consequently the show enjoyed far more impact than it does today, swamped as it now is by innumerable rivals (some of the best of which are mounted by the Royal Academy itself). Turner quickly provoked highly favourable responses to his vivacious and inventive offerings. In 1791 he briefly supplemented his income by working as a scene painter at the Pantheon Opera House in Oxford Street. This contact with the theatre bore long-term dividends by demonstrating that the covering of large areas of canvas held no terrors, that light could be used dramatically and that the stage positionings of actors and props could usefully be carried over to the staffing of images. Thus in his mature works Turner would often place his figures and/or objects in downstage left, centre and right locations when he especially wanted us to notice them.

Tom Tower, Christ Church, Oxford

1792
watercolour, 27.2 x 21.5 cm
Turner Bequest, Tate Britain, London

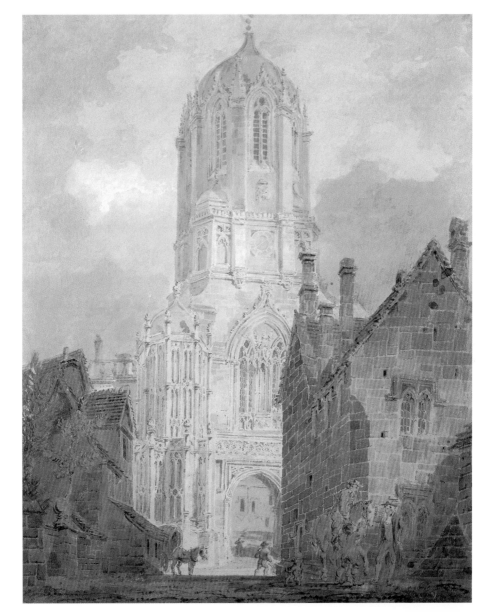

At the 1792 Royal Academy Exhibition Turner also received a lesson that would eventually move his art into dimensions of light and colour previously unknown to painting. He was especially struck by a watercolour, *Battle Abbey*, by Michael Angelo Rooker ARA (1746-1801), and copied it twice in watercolour (the Rooker is today in the Royal Academy collection, London, while both of Turner's copies reside in the Turner Bequest). Rooker was unusually adept in minutely differentiating the tones of masonry (tone being the range of a given colour from light to dark). The exceptionally rich spectrum of tones Rooker had deployed in his *Battle Abbey* demonstrated something vital to Turner. He emulated Rooker's multiplicity of tones not only in his two copies but also in many elaborate drawings made later in 1792. Very soon the young

St Anselm's Chapel, with part of Thomas-à-Becket's
Crown
Canterbury Cathedral

RA 1794
watercolour, 51.7 x 37.4 cm
Whitworth Art Gallery, Manchester, U.K

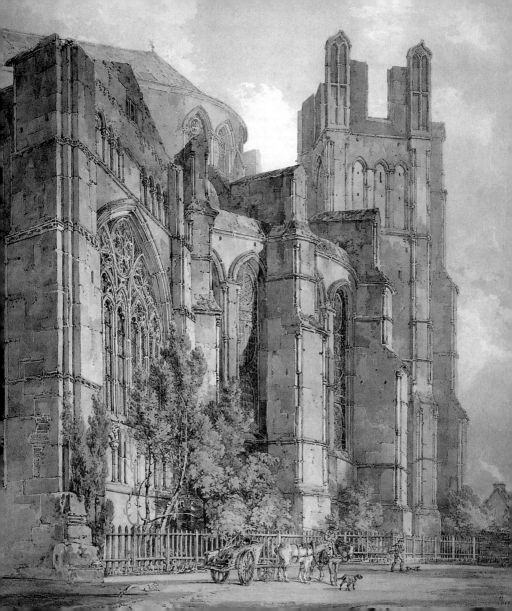

artist attained the ability to differentiate tones with even more subtlety than the master he emulated.

The technical procedure used for such tonal variation was known as the 'scale practice', and it was rooted in the inherent nature of watercolour. Because watercolour is essentially a transparent medium, it requires its practitioners to work from light to dark (for it is very difficult to place a light mark over a darker one but not the reverse). Instead of mixing up a palette containing all of the many tones he required for a given image, Turner instead copied Rooker and mixed up merely one tone at a time before placing it at *different* locations across a sheet of paper. Then, while that work dried, he would take some of the remaining tonal mixture off his palette and brush it onto various locations in further watercolours, which were laid out around

Fishermen at Sea

RA 1796
oil on canvas, 91.5 x 122.4 cm
Turner Bequest, Tate Britain, London

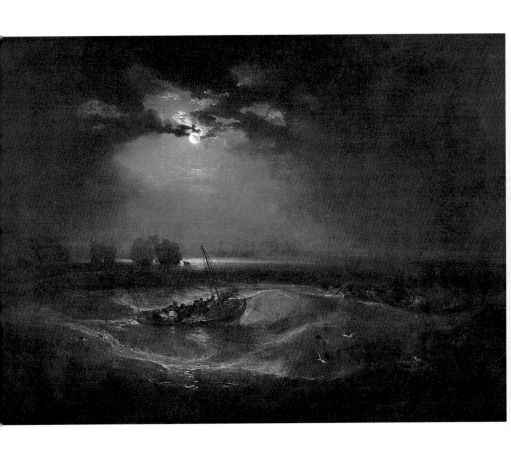

his studio in a production line. By the time he returned to the first drawing it would have dried. Turner would then slightly darken the given colour on his palette and add the next 'note' down the tonal 'scale' from light to dark to this work and its successors.

Naturally, such a process saved enormous time, for it did not require the simultaneous creation of a vast range of tones, which would also have required a huge palette and a multitude of brushes, one for each tone. And as well as permitting the production of large numbers of watercolours, this procedure helped with the reinforcement of spatial depth, for because the finishing touches would always be the darkest tones mixed on a palette, their placement in the foreground of an image would help suggest the maximum degree of recession beyond them.

Llandaff Cathedral, South Wales

RA 1796
watercolour, 35.7 x 25.8 cm
British Museum, London

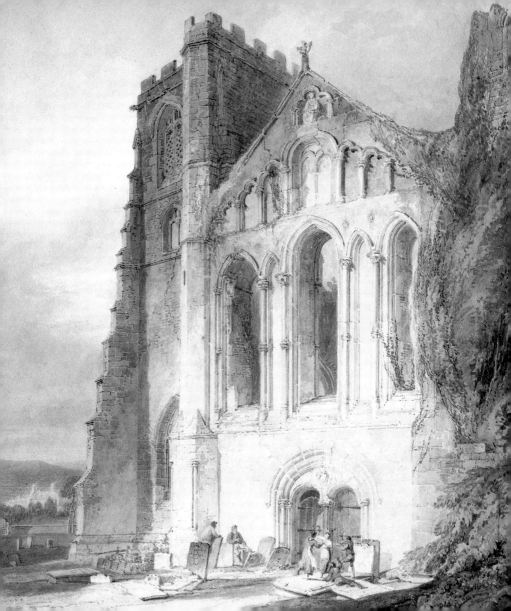

Before too long Turner would enjoy an unrivalled ability to differentiate the most phenomenally minute degrees of light and dark, and eventually he would become the most subtle tonalist in world art.

In a good many watercolours created after the summer of 1792 the ability to create subtle tonal distinctions within an extremely narrow range of tones from light to dark already permitted Turner to project a dazzling radiance of light (for very bright light forces tones into an extremely constricted tonal band). And eventually tonal differentiation would free the artist to move into new realms of colour. Thus many of the very late works reproduced in this book are all flooded with fields of pure colour, within which only slightly lighter or darker variants of the same colour were used to denote the people, objects,

Wolverhampton, Staffordshire

RA 1796
watercolour, 31.8 x 41.9 cm
Art Gallery and Museum, Wolverhampton

landscapes and seascapes existing within those areas. Despite the tonal delicacy with which such forms are depicted, they all seem fully concrete. Increasingly, Turner's powers as a colourist would become stronger and ever more sophisticated, especially after his first visit to Italy in 1819. By the latter half of his life he would develop into one of the finest and most inventive colourists in European painting. That development began early in life, and initially as a result of seeing Rooker's *Battle Abbey* in 1792. Turner always took what he required from other artists, and the Rooker watercolour gave him exactly what he wanted just when he needed it most.

In 1793 the Royal Society of Arts awarded the seventeen-year-old its 'Greater Silver Pallet' award for landscape drawing. By now the youth was selling works easily, and he

Trancept of Ewenny Priory, Glamorganshire

RA 1797
watercolour, 40 x 55.9 cm
National Museum of Wales, Cardiff

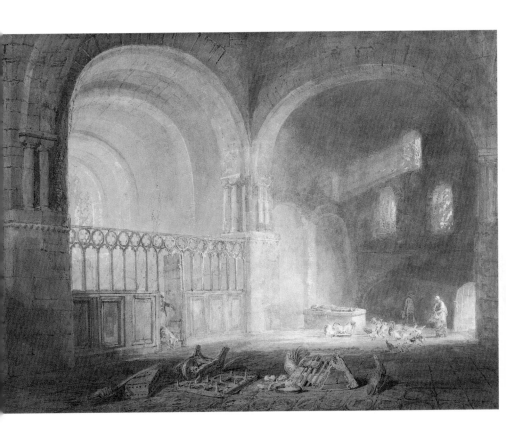

supplemented his income throughout the 1790s by giving private lessons. And on winter evenings between 1794 and 1797 he met with various artists – including another leading young watercolourist, Thomas Girtin (1775-1802) – at the home of Dr Thomas Monro. This physician was a consultant to King George III and a doctor specialising in mental illness who would later treat Turner's mother. (She would subsequently die in his care in 1804.) Monro had established an unofficial artistic 'academy' in his house in Adelphi Terrace overlooking the Thames, and he paid Turner three shillings and sixpence per evening plus a supper of oysters to tint copies made in outline by Girtin from works by a number of artists, including Antonio Canaletto (1697-1768), Edward Dayes (1763-1804), Thomas Hearne (1744-1817) and John Robert Cozens (1752-

Self-Portrait

1798
oil on canvas, 74.5 x 58.5 cm
Turner Bequest, Tate Britain, London

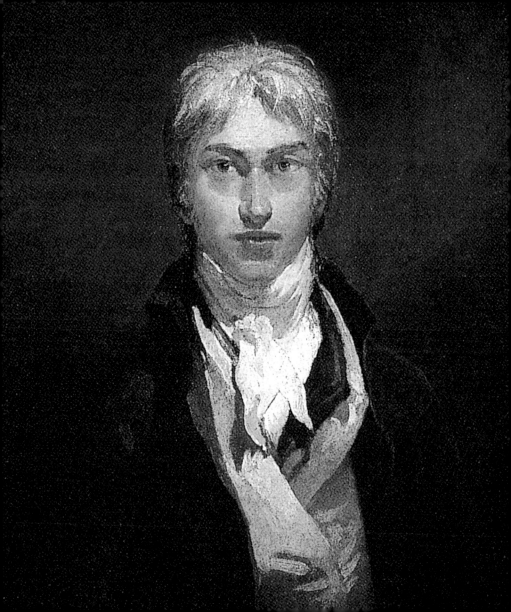

1797), who at the time was a mental patient under the supervision of Dr Monro. Naturally, Turner absorbed the influence of all these painters, and the breadth of Cozens's landscapes particularly impressed him, as it did Tom Girtin.

Further important artistic influences upon Turner during the 1790s were Thomas Gainsborough RA (1727-1788), Philippe Jacques de Loutherbourg RA (1740-1812), Henry Fuseli RA (1741-1825) and Richard Wilson RA (1713?-1782). Gainsborough's Dutch-inspired landscapes led Turner to a liking for those selfsame types of scenes, while de Loutherbourg especially influenced the way that Turner painted his figures, varying their style according to the type of images in which they appeared. Fuseli's approach to the human form may occasionally be detected in Turner's works as well.

The Dormitory and Transcept
of Fountain's Abbey – Evening

1798
watercolour, 45.6 x 61 cm
York City Art Gallery

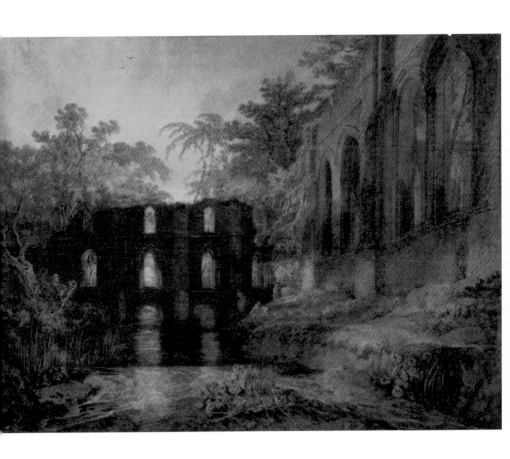

An appreciation of the pictures of Richard Wilson, who had grafted an Italianate style onto British scenery, soon led Turner to a passionate liking for the works of Claude Gellée (known as Claude le Lorrain, 1600-1682) who had heavily influenced Wilson and who proved to be the most enduring pictorial influence upon Turner for the rest of his life. Yet from his mid-teens onwards, one overriding aesthetic influence came to shape Turner's thinking about his art, and not surprisingly it derived from within the Royal Academy itself, albeit mostly through reading rather than from being imparted directly. This was the influence of Sir Joshua Reynolds.

Turner had attended the last of Reynolds's lectures or discourses in December 1790, and from reading the rest of them he seems to have assimilated or responded to all of

View of Salisbury Cathedral
from the Bishop's Garden

1798
pencil and watercolour
51.3 x 67.8 cm, 47.4 x 64.5 cm
Trustees of the Harewood House Trust

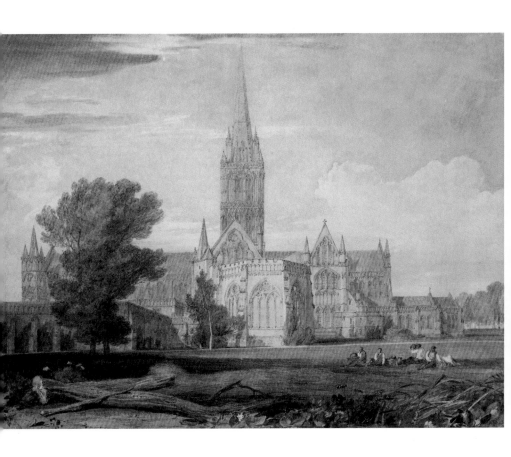

Reynolds's lessons concerning the idealizing aspirations for art that were so eloquently set forth in those fifteen talks. In order to understand Turner's overall creative development, it is vital to perceive it in the context of Reynolds's teachings.

In his discourses Reynolds not only set forth a comprehensive educational programme for aspiring artists; he also upheld the central idealizing doctrine of academic art that had evolved since the Italian Renaissance. This can validly be termed the Theory of Poetic Painting. It maintained that painting and sculpture are disciplines akin to poetry, and that their practitioners should therefore attempt to attain an equivalence to the profound humanism, mellifluity of utterance, aptness of language, measure and imagery, grandeur of scale, and moral discourse of the most exalted poetry and poetic dramas.

Abergavenny Bridge, Monmouthshire,
Clearing up after a Showery Day

────────────────────────

1799
pencil and watercolour, gouache
41.3 x 76 cm
Trustees of the Harewood House Trust

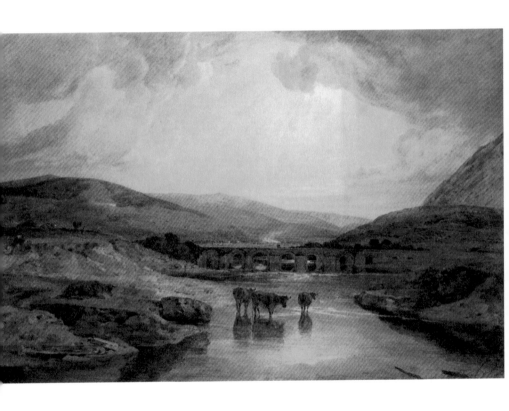

From the mid-1790s onwards we encounter Turner setting out to realise all of these ambitions. Thus his landscapes and seascapes rarely lack some human dimension after this time, and frequently their subject-matter is drawn from history, literature and poetry. The images are also increasingly structured to attain the maximum degrees of visual consonance, coherence and mellifluity. The visual equivalent to the aptness of language, measure and imagery encountered in poetry (and to the additional appropriateness of gesture and deportment found in poetic dramas, such as the plays of Shakespeare) was known as 'Decorum' in the aesthetic literature known to Reynolds and Turner. Many of the latter's favourite landscape painters, particularly Claude, Nicholas Poussin (1594-1665) and Salvator Rosa (1615-1673), had often observed such Decorum

Constance

―――――――

1842
watercolour, 30.4 x 45.4 cm
York City Art Gallery

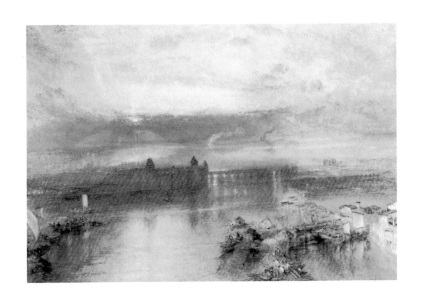

through matching their times of day, light and weather-effects to the central meanings of their pictures. By 1800 Turner had also begun to create such appropriateness, and an example of this procedure can be witnessed in the watercolour of Caernarfon Castle displayed at the Royal Academy in that year; as in a particularly ingenious observance of Decorum, *Pope's Villa at Twickenham* of 1808 and a far better-known later example, *The Fighting 'Temeraire'* of 1839.

Decorum is an associative method, and because Turner possessed an unusually connective mind, he always found it easy to match times of day, light and weather-effects most appropriately to the meanings of his pictures. He also imbued many of his works with associative devices commonly encountered in poetry. These are allusions, or subtle hints at

Dolbadern Castle, North Wales

1800
oil on canvas, 119.5 x 90.2 cm
Royal Academy of Arts, London

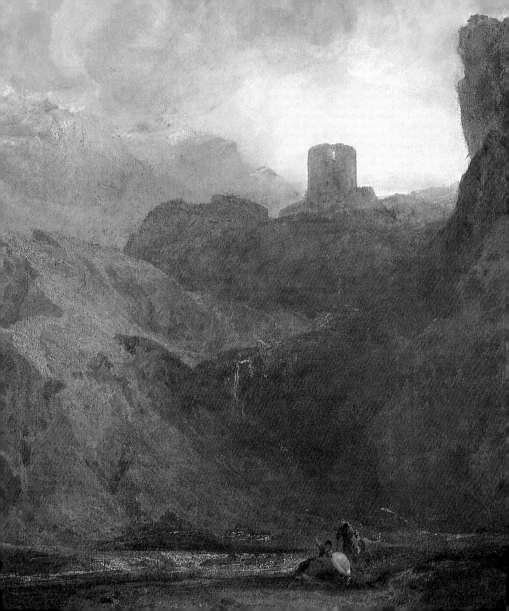

specific meanings; puns or plays upon the similarity of appearances; similes or direct comparisons between forms; and metaphors, whereby something we see doubles for something unseen. Occasionally Turner could even string together his visual metaphors to create complex allegories. Here Turner was again following Reynolds, who in his seventh Discourse had suggested that, like poets and playwrights, painters and sculptors should use 'figurative and metaphorical expressions' to broaden the imaginative dimensions of their art.

In the final, 1790 Discourse attended by Turner, Reynolds had especially celebrated the grandeur of Michelangelo's art. As early as 1794 Turner began doubling or trebling the size of objects and settings he represented (such as trees, buildings, ships, hills and mountains) in order to aggrandize them greatly.

Caernarvon Castle, North Wales

RA 1800
watercolour, 66.3 x 99.4 cm
Turner Bequest, Tate Britain, London

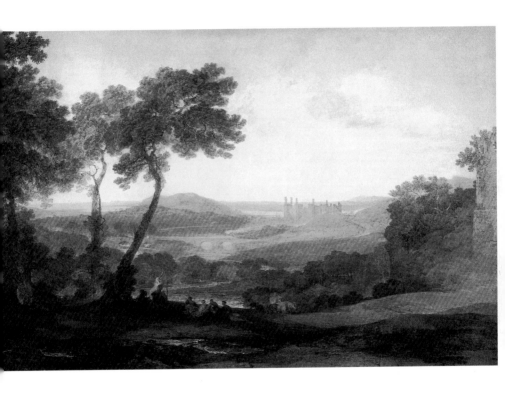

He would continue to do so for the rest of his life, in ways that ultimately make his landscapes and seascapes seem every bit as grand as the figures of Michelangelo.

And by 1796, with a watercolour of Llandaff cathedral, Turner also began making moral points in his works. Often he would comment upon both the brevity of human life and of our civilisations, our frequent indifference to that transience, the destructiveness of mankind, and on much else besides. To that end, and equally to expand the temporal range of his images, from 1800 onwards he started making complementary pairs of works; usually these were on identically-sized supports and created in the same medium, although not invariably so (for example, see the *Dolbadern Castle* and *Caernarvon Castle*, which are respectively an oil and a watercolour). In these and

Sunshine on the Tamar

1800
watercolour, 21.7 x 36.7 cm
Ruskin School Collection

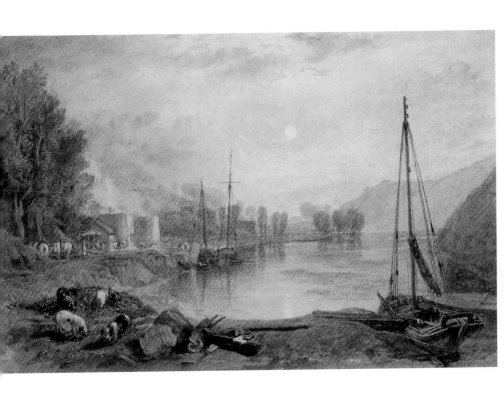

other ways he responded keenly to Reynolds's demand that artists should be moralists, putting human affairs in a judgemental perspective. And linked to the moralism was Reynolds's admonition that artists should not concern themselves with arbitrary or petty human experience but instead investigate the universal truths of our existence, as they are commonly explored in the highest types of poetry and poetic drama. To further this end, Reynolds entreated artists to go beyond the emulation of mere appearances and convey what Turner himself would characterise in an 1809 book annotation as 'the qualities and causes of things', or the universal truths of behaviour and form.

Dutch Boats in a Gale:
Fishermen Endeavouring to put Their Fish on Board
('The Bridgewater Seapiece')

RA 1801
oil on canvas, 162.5 x 222 cm
Private Collection, on loan to the National Gallery, London

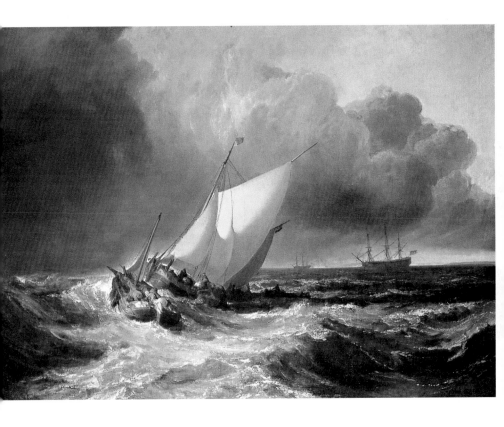

We shall return to Turner's approach to the universals of human existence presently. But from the mid-1790s onwards he began to express 'the qualities and causes of things' in his representations of buildings, as can readily be seen in the 1794 watercolour of *St Anselm's Chapel, Canterbury*. In works like this we can already detect a growing comprehension of the underlying structural dynamics of man-made edifices. Within a short time, in watercolours such as the *Trancept of Ewenny Priory, Glamorganshire* of 1797, this insight would become complete. And because Turner believed that the underlying principles of manmade architecture derived from those of natural architecture, it was but a short step to understanding geological structures too.

Interior of Salisbury Cathedral,
Looking Towards the North Transept

c. 1802-05
watercolour, 66 x 50.8 cm
Salisbury and South Wiltshire Museum

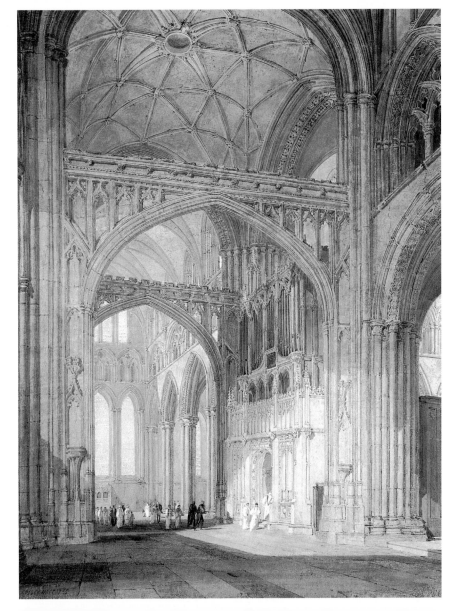

49

Certainly, Turner made apparent the 'qualities and causes' of the latter types of forms by early in the following century (for example, see the rock stratification apparent in *The Great Fall of the Riechenbach, in the valley of Hasle, Switzerland* of 1804).

From the mid-1790s onwards we can simultaneously detect Turner's thorough apprehension of the fundamentals of hydrodynamics. The *Fishermen at Sea* of 1796 demonstrates how fully the painter already understood wave-formation, reflectivity and the underlying motion of the sea. From this time onwards his depiction of the sea would become ever more masterly, soon achieving a mimetic and expressive power that is unrivalled in the history of marine painting. Undoubtedly there have been, and still are many marine painters who have

South View from the Cloisters, Salisbury Cathedral

c. 1802
watercolour, 68 x 49.6 cm
Victoria and Albert Museum, London
This is another of the set of large views
of the cathedral made for Sir Richard Colt Hoare

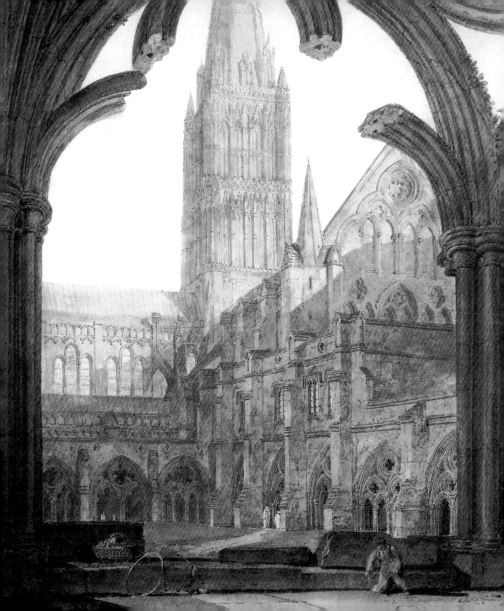

gone far beyond Turner in the degrees of photographic realism they have brought to the depiction of the sea. Yet none of them has come within miles – nautical miles, naturally – of expressing the fundamental behaviour of water. By 1801, when Turner exhibited 'The Bridgewater Seapiece', his grasp of such dynamics was complete. By that time also the painter had simultaneously begun to master the essential dynamics of cloud motion, thereby making apparent the fundamental truths of meteorology, a comprehension he fully attained by the mid-1800s. Only his trees remained somewhat mannered during the decade following 1800. However, between 1809 and 1813 Turner gradually attained a profound understanding of the 'qualities and causes' of arboreal forms, and thereafter replaced a rather old-fashioned mannerism in his depictions of

Calais Pier, with French Fishermen Preparing for Sea:
an English Packet Arriving

RA 1803
oil on canvas, 172 x 240 cm
Turner Bequest, National Gallery, London

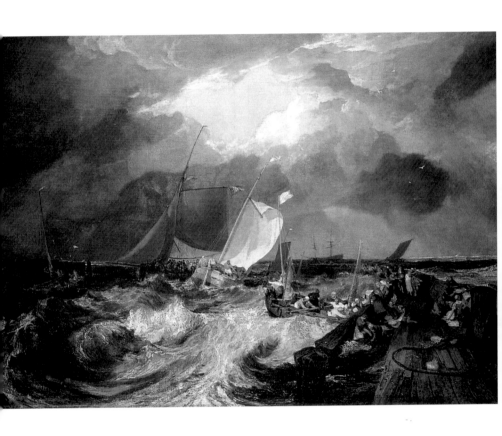

trunks, boughs and foliage with a greater sinuousness of line and an increased sense of the structural complexity of such forms. By 1815 that transformation was complete, and over the following decades, in works such as *Crook of Lune, looking towards Hornby Castle* and the two views of Mortlake Terrace dating from 1826 and 1827, Turner's trees would become perhaps the loveliest, most florescent and expressive natural organisms to be encountered anywhere in art.

All these various insights are manifestations of Turner's idealism, for they subtly make evident the ideality of forms, those essentials of behaviour that determine why a building is shaped the way it is in order to stand up, why a rockface or mountain appears as it does structurally, what forces water to move as it must, what determines the way clouds are shaped

High Street, Oxford

1803
oil on canvas, 68.5 x 100.3 cm
Loyd Collection

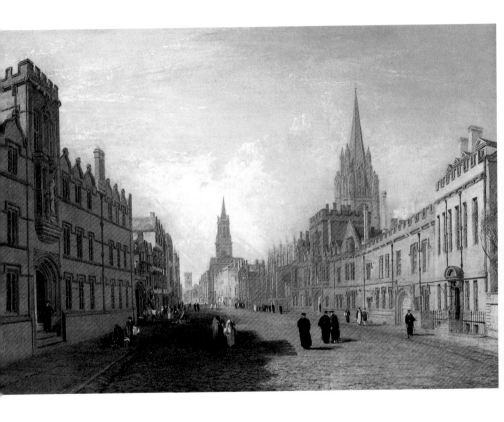

and move, and what impels plants and trees to grow as they do. No artist has ever matched Turner in the insight he brought to these processes. This was recognised even before his death in 1851 by some astute critics, especially John Ruskin who in his writings extensively explored the artist's grasp of the 'truths' of architecture, geology, the sea, the sky and the other principal components of a landscape or marine picture.

In order to create idealised images, throughout his life Turner followed a procedure recommended by Reynolds. This was ideal synthesis, which was a way of overcoming the arbitrariness of appearances. Reynolds accorded landscape painting a rather lowly place in his artistic scheme of things because he held landscapists to be mainly beholden to chance: if they visited a place, say, when it happened to be raining,

Richmond Hill

c. 1825
watercolour, 29.7 x 48.9 cm
Lady Lever Art Gallery, Port Sunlight, Cheshire

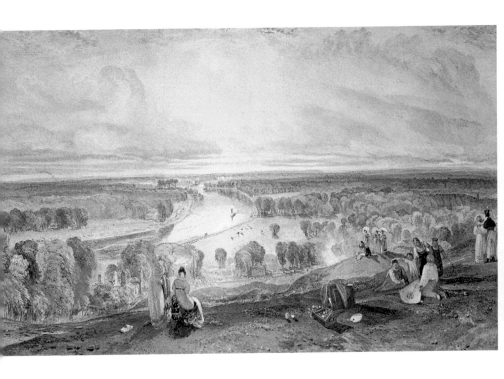

then that was how they would be forced to represent it if they were at all 'truthful'. In order to avoid this arbitrariness, Reynolds recommended another kind of truth in landscape painting. This was the practice of landscapists like Claude le Lorrain, who had synthesized into fictive and ideal scenes the most attractive features of *several* places as viewed in the most beautiful of weather and lighting conditions, thus transcending the arbitrary. Although Turner gave more weight to representing individual places than Reynolds was prepared to permit, this individuation was largely offset by a wholehearted adoption of the synthesizing practice recommended by Reynolds (so much so that often his representations of places bore little resemblance to actualities). As Turner would state around 1810:

The Passage of Mount St Gothard,
Taken from the Centre of the Teufels Broch
(Devil's Bridge), Switzerland

signed and dated 1804
watercolour, 98.5 x 68.5 cm
Abbot Hall Art Gallery, Kendal, Cumbria

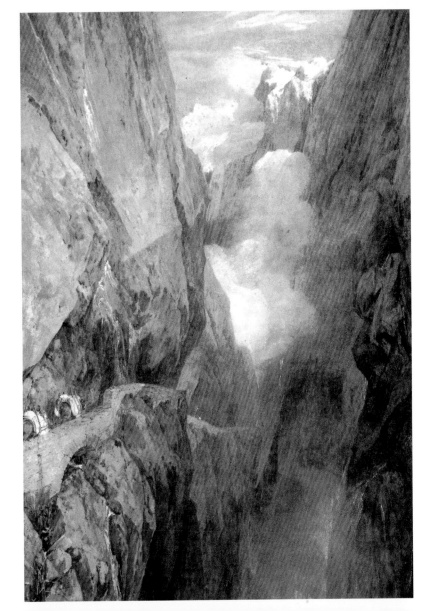

'To select, combine and concentrate that which is beautiful in nature and admirable in art is as much the business of the landscape painter in his line as in the other departments of art.'

And Turner equally overcame arbitrariness by employing his unusual powers of imagination to the full. He stated his belief in the supremacy of the imagination in a paraphrase of Reynolds that stands at the very core of his artistic thinking:

'...it is necessary to mark the greater from the lesser truth: namely the larger and more liberal idea of nature from the comparatively narrow and confined; namely that which addresses itself to the imagination from that which is solely addressed to the Eye.'

The Shipwreck

1805
oil on canvas, 170.5 x 241.5 cm
Turner Bequest, Tate Britain, London

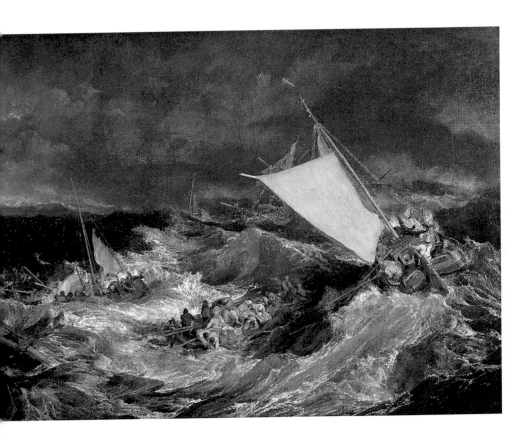

Yet this does not mean that Turner neglected the eye. He was an inveterate sketcher, and there are over 300 sketchbooks in the Turner Bequest, incorporating over 10,000 individual sketches. Often he would sketch a place even if he had sketched it several times before. By doing so he not only mastered the appearances of things but also honed his unusually retentive memory, which is a crucial tool for an idealizing artist, inasmuch as memory sifts the essential from the inessential.

Turner's principal method of studying appearances and still allowing himself room for imaginative manoeuvre was to sketch a view in outline, omitting any effects of weather and light, or even its human and other live inhabitants (if needed, those ancillaries could be studied separately). He would then

The Thames near Walton Bridges

c. 1805
oil on plaster, 37 x 73.5 cm
Turner Bequest, Tate Britain, London

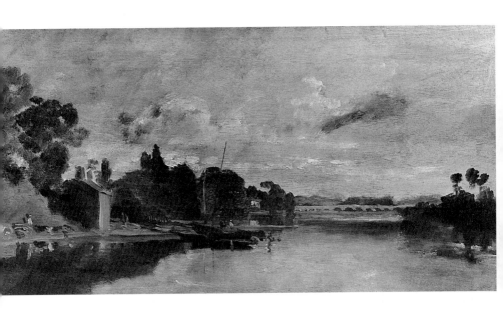

63

return to the sketch at a later date, supplying many visual components of the scene mainly from memory and/or the imagination. Turner kept all his sketchbooks for later reference, and sometimes he would return to them as much as forty years after they were first used in order to obtain the factual data for an image. This practice began in the early 1790s, and it is easy to perceive how it grew directly out of the idealizing admonitions of Reynolds.

And another, higher kind of idealisation grew out of Reynolds's teachings as well. From fairly early on in his career Turner came to believe that ultimately forms enjoy a metaphysical, eternal and universal existence, independent of man. This apprehension first formed through the analysis of architecture. Like many before him, Turner maintained that not

Sun Rising Through Vapour;
Fishermen Cleaning and Selling Fish

RA 1807
oil on canvas, 134.5 x 179 cm
Turner Bequest, National Gallery, London

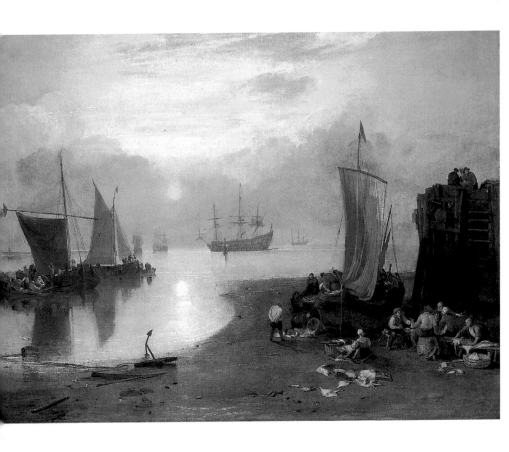

only is there a profound linkage between man-made architecture and natural architecture, but that a universal geometry underlies both. After the mid-1790s this belief was fuelled by a close reading of poetry, most particularly the verse of Mark Akenside, whose long poem 'The Pleasures of the Imagination' states a Platonic idealism with which Turner completely identified, with momentous results for his art.

In post-1807 perspective lecture manuscripts, Turner wrote of the artistic necessity of making earthly forms approximate to such 'imagined species' of archetypal, Platonic form. He followed many others in characterising these ultimate realities as 'Ideal beauties'. From such an apprehension it was easy for him eventually to believe in the metaphysical power of light, and even – because it is the source of all earthly light and

Pope's Villa at Twickenham

1808
oil on canvas, 91.5 x 120.6 cm
Sudeley Castle, Winchcombe, Gloucestershire, U.K

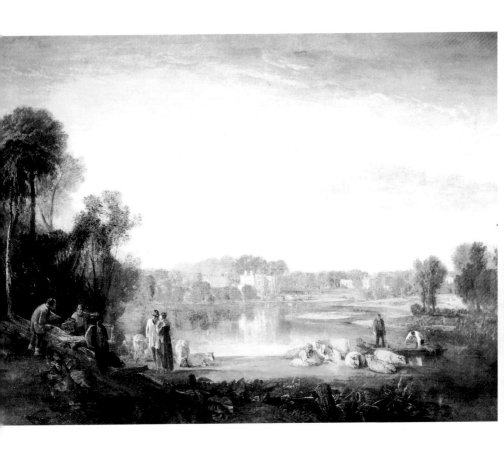

physical existence – that 'The Sun is God' (as he stated shortly before his death). Due to such a viewpoint it is clear that the near-abstraction of Turner's late images is no mere painterly device, despite many recent claims to the contrary. Instead, it resulted from an attempt to represent some higher power, if not even the divinity itself. Turner's idealism was lifelong. Everywhere in his oeuvre, but especially in his later works, we can witness the projection of an ideal world of colour, form and feeling. Not for nothing did a writer in 1910 imagine that if Plato could have seen a Turner landscape, he would 'at once have given to painting a place in his Republic'.

Only in one important respect did Turner depart from the teachings of Reynolds: his representations of the human figure. Another reason Reynolds held landscape painting in fairly low

Bolton Abbey, Yorkshire

———————————————

1809
watercolour, 27.8 x 39.5 cm
The British Museum, London

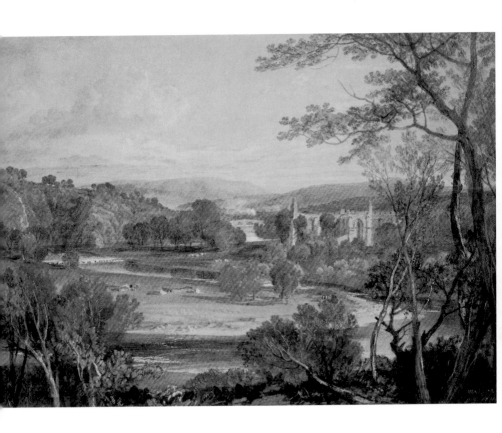

esteem was because it had never said much about the human condition, which for him was necessarily the principal concern of high art. From the outset Turner became intent on disproving him: to imbue landscape and marine painting with the humanism encountered in genres more directly concerned with mankind was his lifelong ambition. But he quickly realised that in order to be absolutely truthful to his own insight into the human condition he would have to reject a central aspect of Reynolds's thinking. For the great teacher, as well as for a host of other academic theorists of like mind, one of the supreme purposes of poetic painting was to exalt mankind through projecting an ideal beauty of human form: to that end Reynolds recommended the creation of beautified physiques similar to those encountered in the works of Michelangelo and other,

The Fall of an Avalanche in the Grisons

1810
oil on canvas, 90 x 120 cm
Turner Bequest, Tate Britain, London

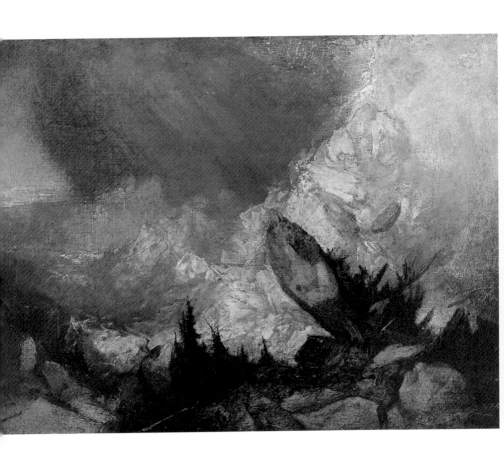

comparable idealising artists. But Turner rejected that central tenet of the Theory of Poetic Painting. Instead he consciously evolved a decidedly unidealised physique for his representations of humanity.

Even by 1794, as in the Canterbury Cathedral view, we can see Turner drawing upon Lowlands painting for the formation of his figures. He especially modelled his people upon those by David Teniers, the Younger (1610-1690). Precisely because of his intentionally boorish people, Teniers had a large following in Britain, especially among members of the upper class, who found them droll (which is why many British country houses still have pictures by Teniers hanging on their walls). In impressive marine paintings such as the 'Bridgewater Seapiece' of 1801, the *Calais Pier* of 1803 and *The Shipwreck* of 1805, Turner

The Wreck of a Transport Ship

c. 1810
oil on canvas, 172.7 x 241.2 cm
Fundaçao Calouste Gulbenkian, Lisbon
With this picture Turner exhausted his need to express himself
by means of ferocious shipwreck scenes, for with one excep-
tion he did not paint such a subject for another twelve years

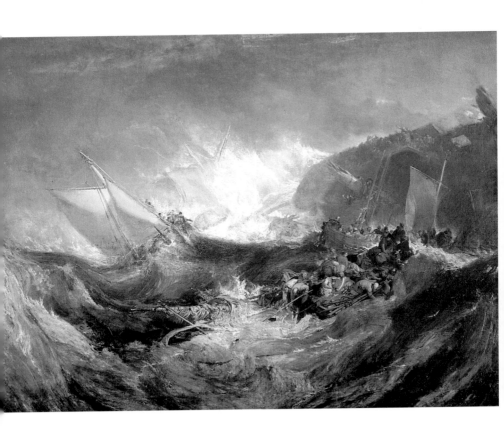

consciously imitated the appearance of Teniers's figures in order to state the central moral contrast of his entire art as far as humanity is concerned: the world around us may be immense, beautiful, ugly, peaceful, ferocious or whatever, but humankind is small, vain and of exceedingly limited strength within that surround. For Turner we are not the 'lords of creation'. Far from it. Instead, we are merely insignificant specks of matter in an often hostile and always indifferent universe. We may try to overcome the forces of external nature, but such attempts are both a cosmic and a comic self-delusion. To point up this 'fallacy of hope' Turner constantly made us look as imperfect, gauche, crude, child-like or even doll-like as possible, just as Teniers and other painters influenced by that Flemish artist (including de Loutherbourg)

Snow Storm:
Hannibal and His Army Crossing the Alps

RA 1812
oil on canvas, 146 x 237.5 cm
Turner Bequest, Tate Britain, London

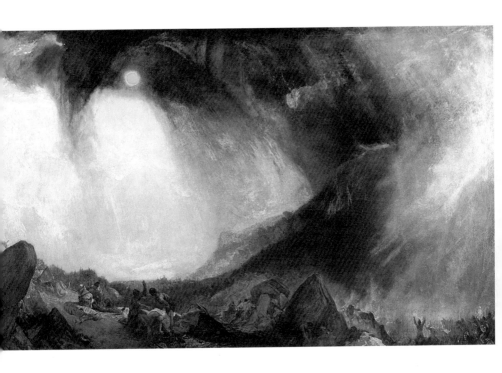

had represented us. In this respect he was consciously turning his back on a dominant aspect of the academic idealism propounded by Reynolds, namely the formation of beautified human archetypes. But if Turner had filled his works with heroic, Michelangelesque figures, those people would have severely diminished what he had to say about our lowly place in the universal scheme of things. Instead, by creating an anti-heroic and 'low' model for humanity, Turner not only maximised the contrast between humanity and the natural world beyond us but simultaneously he stated something that is even more intensely truthful and universal about humankind than Reynolds had demanded. Turner lived in an age in which the majority of people were often made ugly by the harshness of survival, and endured tragically short, brutalized,

Frontispiece of 'Liber Studiorum'

1812
mezzotint engraving
Tate Britain, London

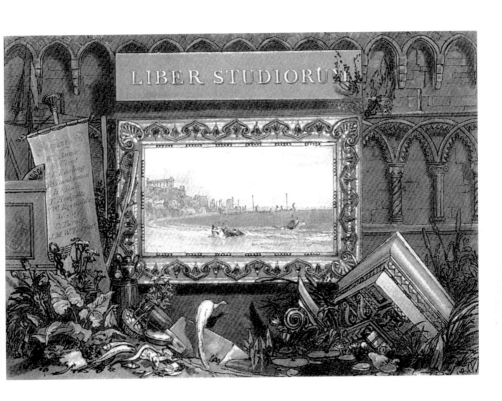

uneducated and anonymous lives. He represented such people countless times, and his consciously imperfect figures are totally congruent with the extremely imperfect lives they led. This is the ultimate form of Turnerian Decorum: a complete matching of human appearances to our underlying realities.

In addition to ideal 'imitation' – the creation of perfected notions of form, which by definition included the expression of the 'qualities and causes' of things – Reynolds had also advocated artistic 'imitation', the absorption of the qualities of the finest masters of past art through imitation of their works stylistically. Here too Turner followed Reynolds assiduously. Throughout his life he emulated the pictorial formulations of a vast range of past (and present) masters, from Titian (1490-1576), Raphael (1483-1520) and Salvator Rosa in the

Mer de Glace, in the Valley of Chamouni, Switzerland

c. 1814
watercolour, 68.5 x 101.5 cm
Yale Center for British Art, New Haven, Conn

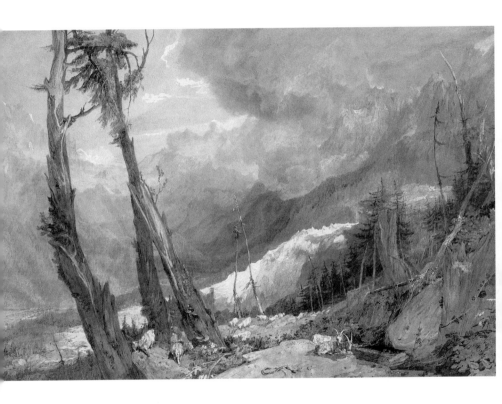

Italian school, to Claude, Nicolas Poussin and Watteau (1684-1721) in the French school, to Rembrandt (1606-1669), Cuyp (1620-1691), van de Velde, the Younger (1633-1707) and Backhuizen (1631-1708) in the Dutch school, to any number of his contemporaries in the English school. Such emulation was not the sign of any imaginative deficiency in Turner, and even less was it due to him being possessed of a supposed inferiority complex that led to rivalry with his betters, as has often been suggested. Turner was merely following Reynolds's teachings and example. It is a mark of his creative vision that whomsoever he emulated, the results always ended up looking thoroughly Turnerian (even if they might well fall short of their models qualitatively).

Dido Building Carthage;
or, the Rise of the Carthaginian Empire

RA 1815
oil on canvas, 155.5 x 232 cm
Turner Bequest, National Gallery, London

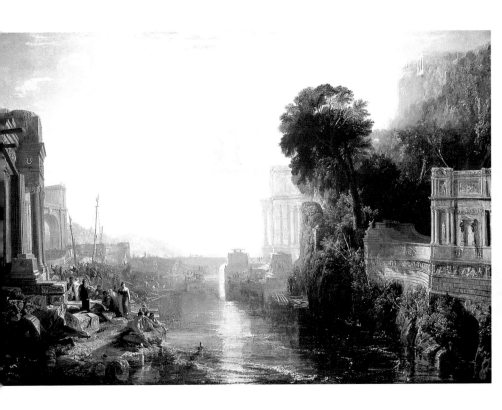

In 1791 Turner made the first of his sketching tours; by the end of his career he would have undertaken more than fifty such tours. During the 1790s alone he ranged over the south of England, the Midlands and the north of England (including the Lake District). He also made five tours of Wales in search of the kind of scenery that Richard Wilson had painted. On each tour he filled a number of sketchbooks with dry topographical studies and the occasional watercolour, from which he would work up elaborate paintings and watercolours back in London.

A memoir of Turner on his sketching tour of Wales and the West Country in 1798 makes his creative priorities very clear:

I recollect Turner as a plain uninteresting youth both in manners and appearance, he was very careless and slovenly

Crossing the Brook

1815
oil on canvas, 193 x 165 cm
Turner Bequest, Tate Britain, London

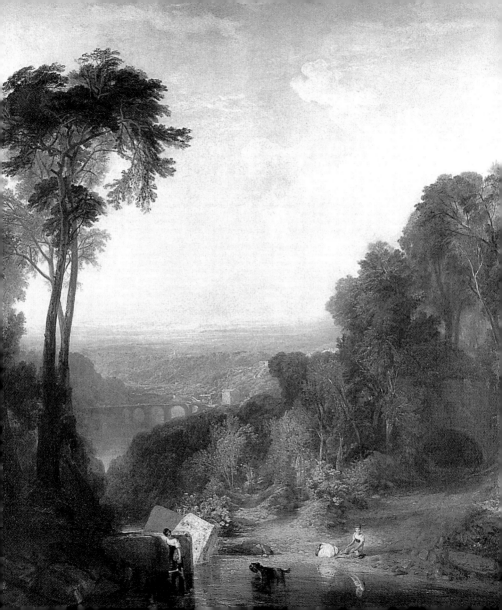

in his dress, not particular what was the colour of his coat or clothes, and was anything but a nice looking young man... He would talk of nothing but his drawings, and of the places to which he should go for sketching. He seemed an uneducated youth, desirous of nothing but improvement in his art...

This view of Turner seems to have been a general one, for it was echoed by the topographical artist Edward Dayes in 1805: 'The man must be loved for his works; for his person is not striking nor his conversation brilliant.' Although Turner's intellect was enormous, his patchy education and wholehearted commitment to his art meant that he cut a poor figure socially, although in time he would polish his edges and gain in public confidence. Emotionally he was remarkably sensitive, for just below the surface lay a deep vulnerability

Norham Castle on the Tweed

1816
mezzotinto engraving for the Liber Studiorum
Tate Britain, London

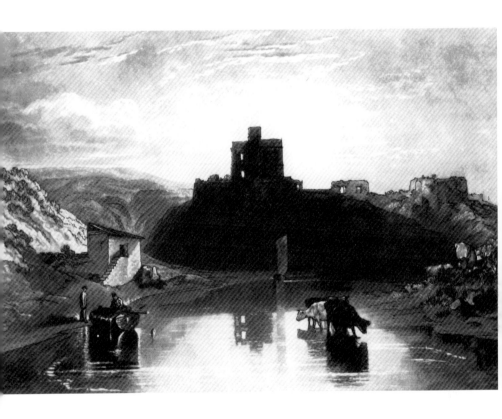

which probably derived from unhappy childhood experiences brought about by the instability of his mother. Such insecurity led Turner always to maintain his emotional defences until he felt he could fully trust people not to hurt him. When he did trust them, however – and he always trusted children – then a completely different side of his personality would emerge. This can be seen in another memoir of the painter as a young man, by his friend Clara Wells:

'Of all the light-hearted, merry creatures I ever knew, Turner was the most so; and the laughter and fun that abounded when he was a lodger in our cottage was inconceivable, particularly with the juvenile members of the family. I remember coming in one day after a walk, and when the servant opened the door the uproar was so great that I asked the servant what was the

The Temple of Jupiter Panellenius Restored

RA 1816
oil on canvas, 116.8 x 177.8 cm
Private Collection, New York

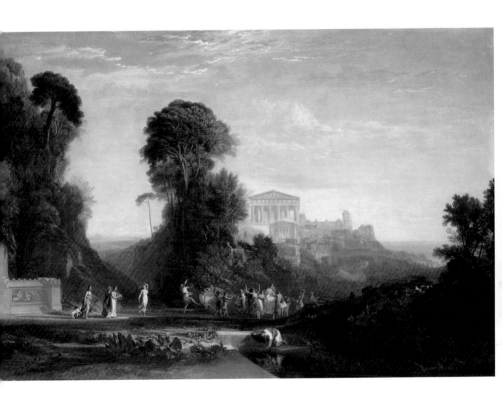

matter. "Oh, only the young ladies (my young sisters) playing with the young gentleman (Turner), Ma'am." When I went into the sitting room, he was seated on the ground, and the children were winding his ridiculously long cravat round his neck; he said, "See here, Clara, what these children are about!"'

Turner's 'home from home' in the cottage of Clara Wells's father, William Wells, at Knockholt in Kent, was the first of several such boltholes he would enjoy throughout his life. By the end of the 1790s, as the insanity of his mother intensified, it must have seemed a vital means of escape for him.

The Decline of the Carthaginian Empire – Rome being determined on the Overthrow of her Hated Rival, demanded from her such Terms as might either force her into War, or ruin her by Compliance: the Enervated Carthaginians, in their Anxiety for Peace, consented to give up even their Arms or their Children

RA 1817
oil on canvas, 170 x 238.5 cm
Turner Bequest, Tate Britain, London

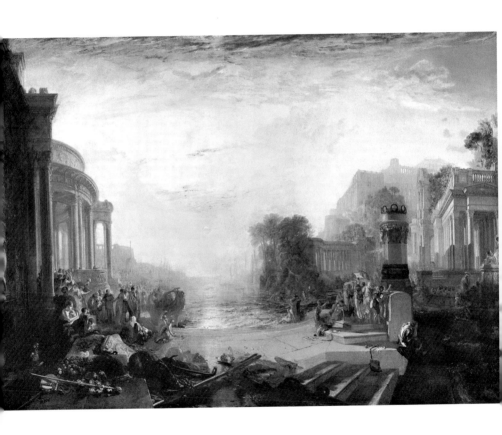

And as soon as he could afford it the painter moved from the parental abode in Maiden Lane, in late 1799 obtaining rooms at 64 Harley Street in a house that eventually he would take over completely.

The 1796 *Fishermen at Sea* was Turner's first exhibited oil painting, and it demonstrates his natural proficiency in the medium. By that date, of course, he had already mastered watercolour, and henceforth he was fully capable of investing it with the same powers of expression and representation more usually to be encountered in oil paint. Similarly, in his oil paintings the artist increasingly obtained the kind of brilliance and luminosity that are more usually to be found in watercolour. But why choose one medium rather than the other? Well, watercolour was fast to work with, and hence

Crook of Lune, Looking Towards Hornby Castle

c. 1817
watercolour, 28 x 41.7 cm
Courtauld Institute of Art, University of London

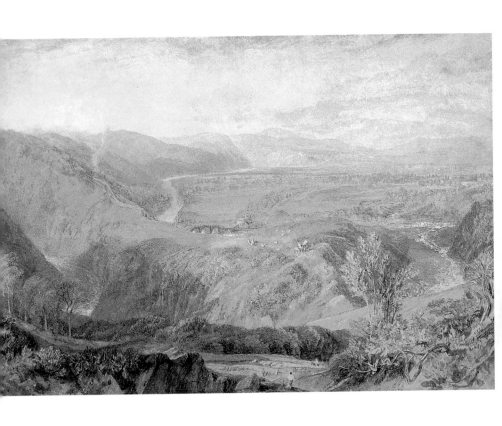

permitted great spontaneity. Its speed of drying also allowed for the creation of large numbers of works within a given timescale, and hence lower prices to the public. Oil paint was slower-drying but more highly regarded culturally and more publicly assertive through its capacity for deployment over much larger surfaces than watercolour. One could also charge far higher prices for oils (which was partially a necessity, as they took much longer to produce).

Turner never rested on his laurels as far as techniques were concerned. In order to extend himself, he would often set himself technical challenges. For example, in the 1820s and '30s he would choose to make sets of watercolours on an unfamiliar kind of support such as a blue or a grey paper. In some of his even later works his trust in new materials (such as

Mount Vesuvius in Eruption

1817
watercolour, 28.6 x 39.7 cm
Yale Center for British Art, New Haven, Conn

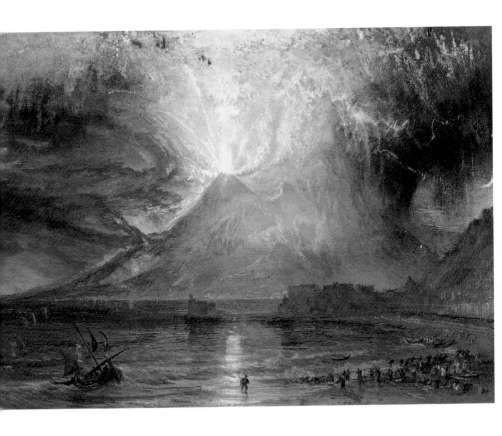

a paint supposedly soluble in either oil or water) would be misplaced, with disastrous results for individual works. Yet his paintings and watercolours are technically sound. And when he was especially inspired, as with *The Fighting 'Temeraire'* of 1839, he would go to great lengths to paint the work as carefully as possible.

In 1798 an alteration to the rules governing the Royal Academy annual Exhibitions allowed artists to include quotations from poetry alongside the titles of their works in the exhibition catalogues. Turner immediately availed himself of this change in order to embark upon a public examination of the roles of painting and poetry, how each discipline could support the other, and where their individual powers resided. In 1798 he appended poetic quotations to the titles of five works;

Marxbourg and Brugberg on the Rhine

1820
watercolour, 29.1 x 45.8 cm
British Museum, London

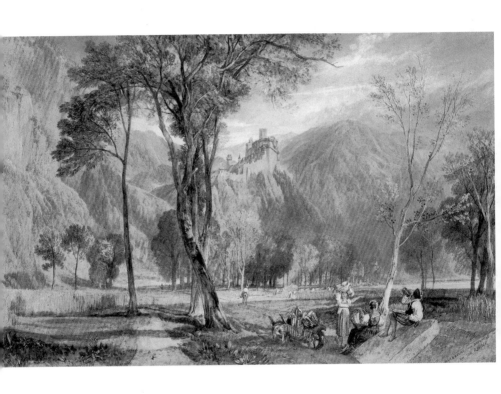

they included verses by John Milton and James Thomson identifying the sun with God. With some of these quotations Turner tested the ways that painting can realize and/or heighten the imagery of poetry, while with others he explored the way that poetic imagery can extend the associations of what we see, and thus move us into realms of imaginative response we cannot reach unaided. In 1799 Turner took this latter process a stage further, employing alongside the titles of five works a poetry that is particularly rich in metaphors in order to extend the images imaginatively into areas that pictorialism cannot explore without verbal help. And in 1800, with two views of Welsh castles, Turner reversed the foregoing procedure by quoting only descriptive poetry that is totally devoid of metaphors; instead, he incorporated the metaphors *into* the

Mosel Bridge at Coblenz

1817
watercolour, 19.9 x 31.1 cm
private collection

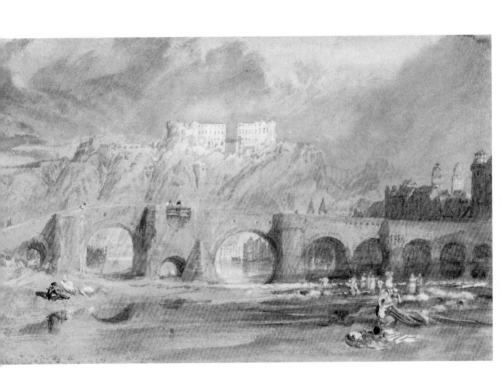

images themselves, thus completing the process of integrating painting and poetry whilst greatly extending the ability of visual images to convey meanings. Thereafter, Turner did not again quote poetry in connection with the titles of his works in the exhibition catalogues for another four years, although when he did so it was to state the internal responses of the people he portrayed, something that again painting cannot fully express without the aid of words. This methodical exploration of the respective powers of painting and poetry was to prove of inestimable value during the rest of Turner's career.

Turner's 1798-1800 investigation of the mechanisms by which pictorial meanings are communicated was equally helped by the close study he made around 1799 of the imagery of Claude le Lorrain. He may have been inspired to

First-Rate, Taking in Stores

1818
watercolour, 28.6 x 39.7 cm
Cecil Higgins Art Gallery, Bedford, U.K

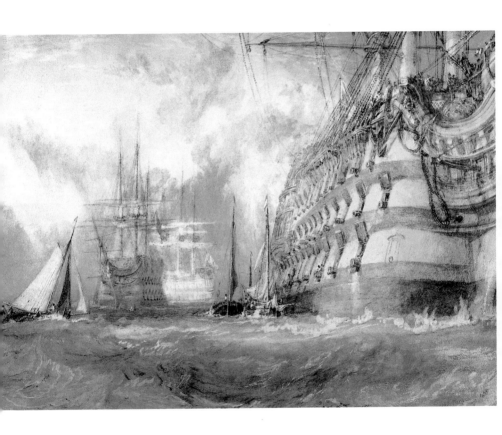

undertake such a detailed analysis by being particularly struck by two paintings by Claude. One was the *Landscape with the Father of Psyche sacrificing at the Milesian Temple of Apollo* (Anglesey Abbey. Cambs) which had just been brought to Britain from Italy, and in front of which Turner was recorded as being 'both pleased and unhappy while he viewed it,– it seemed to be beyond the power of imitation'. The other picture was a seaport scene, *The Embarkation of the Queen of Sheba* (National Gallery, London), that belonged to the wealthy London collector John Julius Angerstein. Turner responded to this painting in a rather dramatic (and wholly characteristic) fashion:

Dort, or Dordrecht,
The Dort Packet-Boat from Rotterdam Becalmed

RA 1818
oil on canvas, 157.5 x 233 cm
Yale Center for British Art

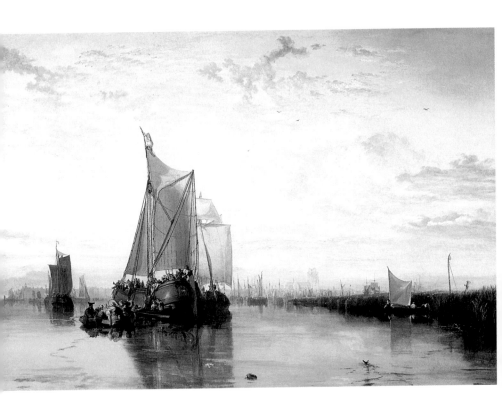

'When Turner was very young he went to see Angerstein's pictures. Angerstein came into the room while the young painter was looking at the *Sea Port* by Claude, and spoke to him. Turner was awkward, agitated, and burst into tears. Mr Angerstein enquired the cause and pressed for an answer, when Turner said passionately, 'Because I shall never be able to paint anything like that picture.'

Turner's analysis of Claude around 1799 was undertaken not only by looking carefully at major oils like these, but also by scrutinizing two books of prints entitled *Liber Veritatis* ('Book of Truth'). This is a set of 200 mezzotints made around 1776 by the London engraver Richard Earlom that reproduces drawings created by Claude upon the completion of each of his mature paintings. The French master greatly utilized visual

The Field of Waterloo

R.A.1818
oil on canvas, 147.5 x 239 cm
Turner Bequest, Tate Britain, London

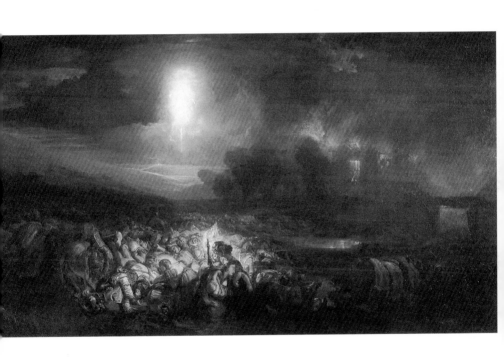

metaphor, and there can be no doubt that Turner recognized a good number of those metaphors, for in time he emulated them very closely indeed. Turner's responsiveness to Claude had a profound effect upon his expressions of meaning, just as it determined the development of many of his compositions and a significant amount of his subject-matter and imagery.

Throughout the 1790s Turner had been obtaining higher and higher prices for his works as demand intensified; an indication of that popularity may be gauged from the fact that by July 1799 he had orders for no less than sixty watercolours on his books. And his increasing status in the marketplace was matched by his growing recognition within the Royal Academy, an esteem that was made official on 4 November 1799 when he was elected an Associate Royal Academician.

Loss of an East Indiaman

c. 1818
watercolour, 28 x 39.5 cm
Cecil Higgins Art Gallery, Bedford, U.K

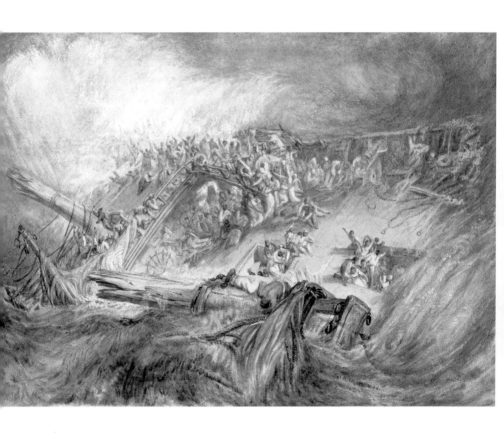

This was a necessary preliminary to becoming a full Academician, and he would not have to wait long before receiving the higher honour.

At the Royal Academy in 1801 Turner made a major contribution towards such an elevation when he exhibited his finest seascape to date, the *Dutch Boats in a Gale: Fishermen endeavouring to put their Fish on Board*, which is also known as 'The Bridgewater Seapiece' after the Duke of Bridgewater who had commissioned it. The work caused a sensation. Reynolds's successor as President of the Royal Academy, Benjamin West (1738-1820), compared it favourably to a Rembrandt, which is quite a compliment for a young painter still making his way in the world. Ultimately the impression created by the picture led to Turner being raised to the status of

Melrose Abbey

1822
pencil and watercolour, 19.5 x 13 cm
private collection

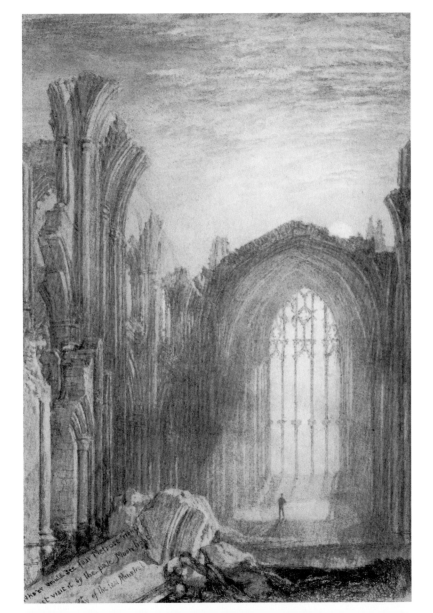

there while see fair Melrose ...
... visit it by the pale Moon...
... of the last Minstrel

a full Royal Academician at the unprecedentedly early age of just twenty-six, on 10 February 1802. Becoming an Academician granted him entry to a very exclusive club indeed, and one with the best of cultural and economic advantages, that of having a highly prestigious marketplace in which automatically to display his works publicly every year without having to submit them to a selection committee.

In the summer of 1801 Turner made an extensive tour of Scotland, the most ambitious trip he had undertaken so far. After his return he showed his Scottish drawings to his fellow landscapist, the painter and diarist Joseph Farington RA, who noted early in 1802 that 'Turner thinks Scotland a more picturesque country to study in than Wales, the lines of the mountains are finer, and the rocks of larger masses'.

Caley Hall

1818
watercolour and gouache, 29.9 x 41.4 cm
National Gallery of Scotland, Edinburgh

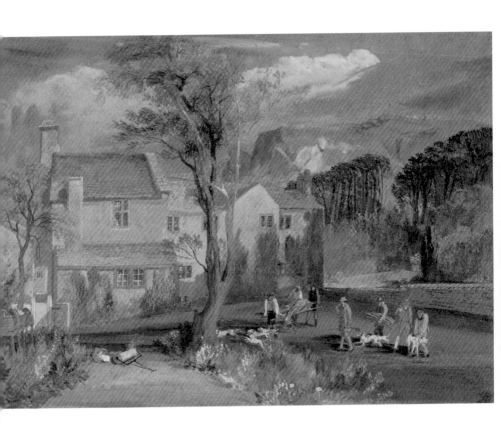

But later that same year Turner had the opportunity to study mountains that greatly dwarfed those of Scotland.

In March 1802 a peace was concluded between Britain and France, after some nine years of war. This allowed tens of thousands of Britons to venture abroad for the very first time. Although Turner had already seen mountains in Wales and Scotland, he knew that if you wish to be staggered by truly majestic heights in Europe then you have to visit the Swiss alps. Accordingly, that was where he made for in the summer of 1802, exploring some of the western cantons and the northern reaches of the Val d'Aosta before making his way to Schaffhausen and Basel. From there he went on to Paris to see the looted treasures Napoleon had installed in the Louvre. In the French capital Turner met Farington, and told him that in

Weathercote Cave when Half Filled with Water

1818
watercolour, 30.1 x 42.3 cm
The British Museum, London

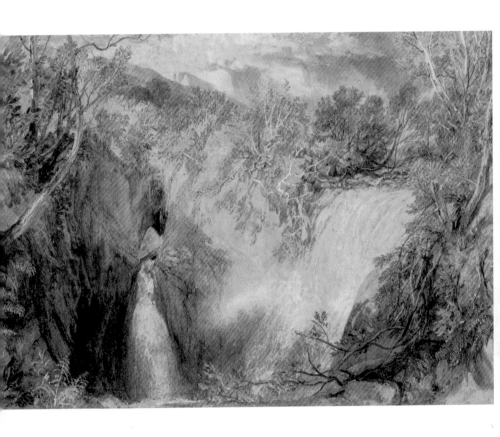

Switzerland he had suffered 'much fatigue from walking, and often experienced bad food & lodgings. The weather was very fine. He saw very fine thunder storms among the mountains.' In the Louvre Turner closely scrutinized works by Poussin, Titian and others, although unfortunately the numerous Claudes in the collection do not seem to have been on display (or perhaps the Englishman simply missed them, which is understandable, given that he must have been tired and suffering from visual indigestion).

Turner began elaborating his responses to Swiss scenery on his return to England. During the winter of 1802-3 he also produced an impressive painting of the view from Calais Pier looking across the English Channel. In the work he made a wittily anti-French statement within a tradition of such sentiments

England:
Richmond Hill on the Prince Regent's Birthday

R.A.1819
oil on canvas, 180 x 334.5 cm
Turner Bequest, Tate Britain, London

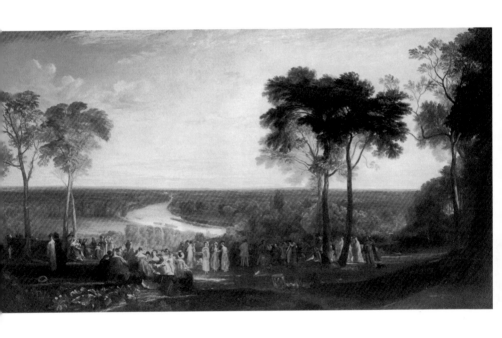

going back to William Hogarth (1697-1764), another artist he particularly admired. Such a secondary purpose was perhaps natural, given that while Turner was busy on the picture all the talk in Britain was of the resumption of hostilities with France.

By this time Turner may have become a father. He always refused to marry, but has long been thought to have sired two daughters, Evelina (1801-1874) and Georgiana (1811-1843). Their mother is thought to have been a Mrs Sarah Danby (1760/66-1861) who was some eleven to fifteen years older than the painter. She was the widow of a London composer of glees and catches, John Danby, who had died in 1798. However, recent research has thrown doubts on the assumptions that the painter had a relationship with Mrs Danby, that he was the father of the two girls, and even that she was their mother. It

The Bell Rock Lighthouse

1819
watercolour and gouache, 30.6 x 45.5 cm
National Gallery of Scotland, Edinburgh

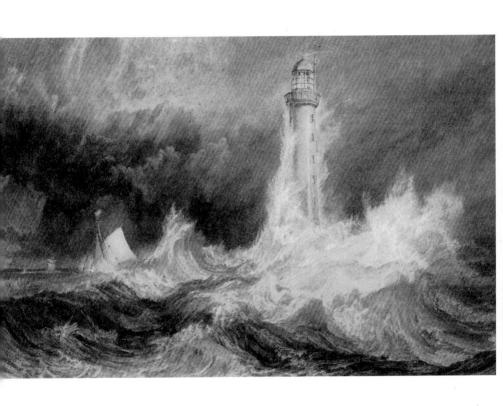

seems equally possible that the artist's father may have sired the two girls. An entry in a church register in Guestling, Sussex for 19 September 1801 records the baptism of Evelina, and gives 'William and Sarah Turner' as the parents; although the painter commonly used William (rather than Joseph) as his forename, it seems equally possible that the record refers to his father. As the older William Turner would only become a widower in 1804, when Evelina was born he still needed to be fairly discreet about any extra-marital relationship he was having (which is perhaps why Evelina was baptised in an out-of-the-way church in deepest Sussex, rather than in London). Sarah Danby suffered from a more powerful need for secrecy, for she received a widow's pension from the Royal Society of Musicians which would have stopped payment had it suspected she enjoyed a

Saint Giorgio Maggiore: Early Morning

1819
watercolour, 22.4 x 28.7 cm
The Tate Gallery, London

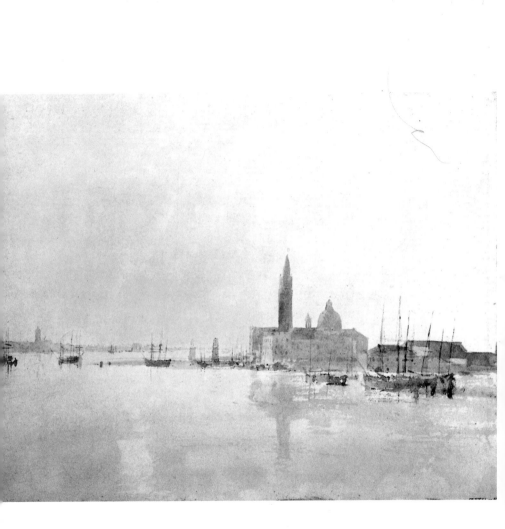

relationship with a man. Certainly J.M.W. Turner left money to the widow in early drafts of his will, but eventually he revoked that bequest, which suggests that he was not the father of the two girls and that she was not their mother. And just to complicate matters even further, perhaps Sarah Danby allowed herself to be thought of as the mother of the two girls in order to protect their true mother, namely her niece, Hannah Danby. This lady always remained unmarried, and therefore had good cause not to be identified as the mother of two illegitimate daughters. She would serve as the painter's housekeeper in one of his London residences from the 1820s onwards, and Turner would leave her a fairly substantial legacy in his will, which perhaps points to her having been the mother of the girls and his having been the father. Nothing is known of Hannah

Rome, From the Vatican
Raffalle, Accompanied by La Fornarina, Preparing His
Pictures for the Decoration of the Loggia

RA 1820
oil on canvas, 177 x 335.5 cm
Turner Bequest, Tate Britain, London

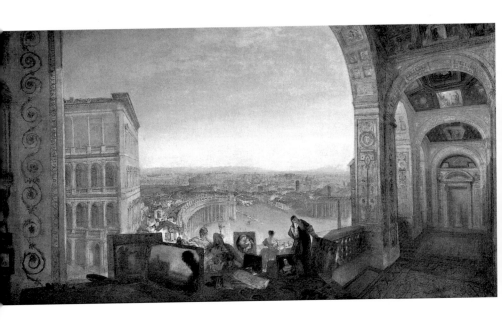

Danby's personality or looks as a young woman, but later in life she seems to have been afflicted with a skin disease, which repelled visitors. In any event, it now seems impossible to determine the true paternity of the girls and the identity of their mother.

Turner was increasingly busy during the 1800s. In 1803 he began constructing a gallery for the display of his works in his house in Harley Street. Clearly he did so because a highly acrimonious political rift had developed within the Royal Academy. This threatened to lose the institution its monarchical status, and thus jeopardised its economic survival (for if the organisation had been demoted in rank, then it would have become just another exhibiting society, which the aristocracy would not have supported to the same degree).

Colour Beginning

1819
watercolour, 22.5 x 28.6 cm
Tate Gallery, London

Turner was merely protecting his economic interests by creating his own gallery. The first show in the new exhibition space opened in April 1804, with as many as thirty works on display. Further annual exhibitions were held there regularly until 1810, and then more spasmodically over the following decade. (During the entire period, however, Turner went on showing works in the Royal Academy simultaneously.)

By early 1805 Turner began residing for parts of the year outside London proper, first at Sion Ferry House in Isleworth, west of London, and then, by the autumn of the following year, nearby at Hammersmith. While living in Isleworth he had a boat built for use as a floating studio upon the Thames, and painted a number of oil sketches in the open air. Although the sketches are very vivacious and prefigure Impressionism,

Marksburg

———————

1817
watercolour on white paper prepared with a grey wash
20 x 31.9 cm
Indianapolis Museum of Art

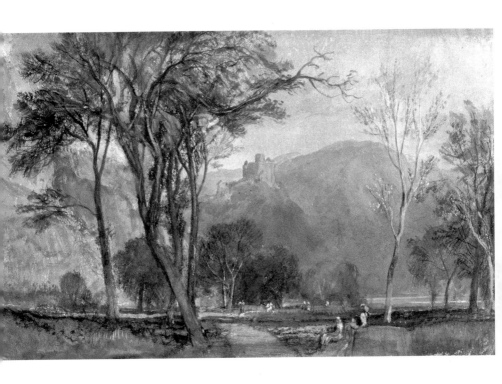

Turner set no store on them and never exhibited them. In 1811 he began building a small villa in Twickenham, also to the west of London. At first he called the property Solus Lodge; later he renamed it Sandycombe Lodge. He designed the house himself and it still survives, although it has been somewhat altered down the years. Between 1802 and 1811 Turner did little touring, being extremely busy producing works for his own gallery and for the Academy, as well as innumerable watercolours on commission. His clientele continued to expand and came to include some of the leading collectors of the day such as Sir John Leicester (later Lord de Tabley) and Walter Fawkes. The latter was a bluff, no-nonsense and very liberal-minded Yorkshireman whose grand country seat, Farnley Hall, near Leeds, Turner began visiting around 1808.

Passage of Mont Cenis

1820
pencil and watercolour, 29.2 x 40 cm
Birmingham Museum and Art Gallery

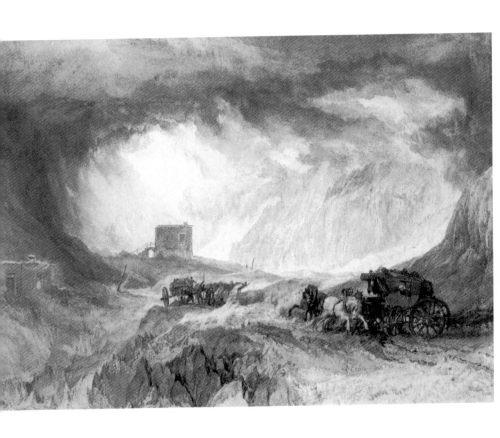

125

Fawkes was perhaps the closest friend Turner ever had amongst his patrons, and the painter went on regularly visiting Farnley until the mid-1820s, becoming very much a part of the Fawkes family and having a room reserved solely for his use.

In 1806 Turner embarked upon a major set of engravings, for which he drew the preliminary etchings himself. This was the *Liber Studiorum* or 'Book of Studies'. Its title not only emulates that of the Claude-Earlom *Liber Veritatis*, but it was mainly created in the identical medium of mezzotint. Originally there were to have been 100 prints in the *Liber Studiorum*. However, by 1819 only 71 of the engravings had been published and the project petered out, although drawings for all the remaining designs were created and proofs of some of the final 29 prints were pulled. Turner was clearly inspired by

More Park, Near Watford, on the Colne

1822
watercolour, 15.7 x 22.1 cm
Turner Bequest, Tate Britain, London

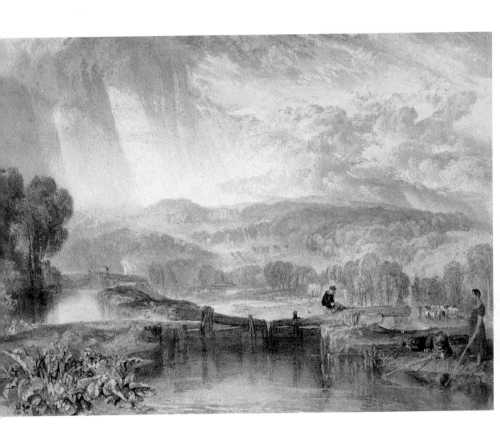

his own close study of the Claude-Earlom model to offer his *Liber Studiorum* as a similar teaching aid for others. In theory this was financially canny, given that at the time there was still a dearth of art schools in Britain and therefore a real need for 'teach yourself' publications beyond the major cities. To further his didactic aims, Turner broke the subjects of the *Liber Studiorum* down into categories, namely Architectural, Marine, Mountainous, Historical, Pastoral and Elevated Pastoral. He employed the last classification to differentiate the pastoralism based on classical myths, such as may be found in the works of Claude and Poussin, from the ruddy and muddy farmyard type to be seen in Lowlands painting and/or mundane reality.

Dover Castle
———————

1822
watercolour, 43.2 x 62.9 cm
Museum of Fine Arts, Boston, Massachusetts

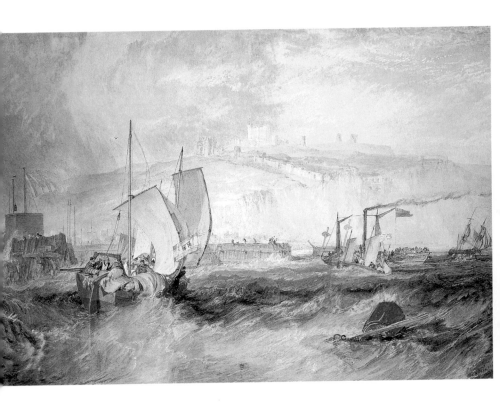

129

At the very end of 1807 Turner took yet another step that was to have enormously beneficial results for his art: he volunteered for the position of Royal Academy Professor of Perspective. In order to do the job he embarked upon a rigorous study programme. This involved reading or re-reading more than 70 books on the science of perspective, and on art and aesthetics. The majority of treatises in the latter two categories subscribe in some degree or other to the Theory of Poetic Painting. The first annual set of six lectures was given in January 1811. Turner went on delivering the lectures spasmodically until 1828 (although he did not resign the professorship until 1838), and the manuscripts of his talks are now in the British Library. They make it clear that the painter did not limit himself to an analysis of perspective.

The Battle of Trafalgar

1822-1824
oil on canvas, 259 x 365.8 cm
National Maritime Museum, Greenwich, U.K

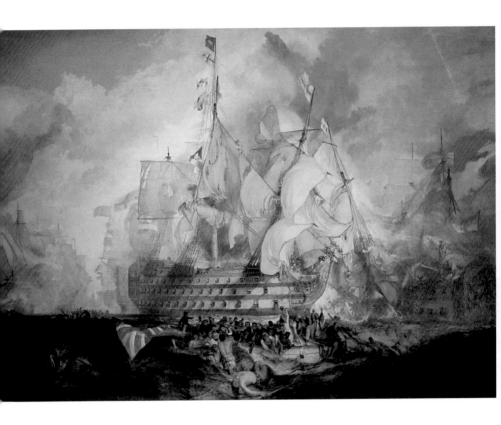

Instead he surveyed a much wider range of subjects. His audiences were mystified, for naturally they wanted to learn about perspective. What they received instead were the Turnerian version of Reynolds's Discourses. (For example, the final lecture in the sequence of talks was a survey of the way Old Master painters had often used landscapes as backgrounds in their pictures.) Yet if the exercise was rather a waste of time for the painter's audiences, it was far from so for Turner himself. The reading for the lectures concentrated his mind wonderfully regarding his identification with the Theory of Poetic Painting, and it especially fired up his idealism, as can be seen in many works created after 1811. The discovery or rediscovery of the potency of idealising ideas on art was not the only stimulus Turner fortuitously received at this time.

The Bay of Baiae:
Apollo and the Sibyl

RA 1823
oil on canvas, 145.5 x 239 cm
Turner Bequest, Tate Britain, London

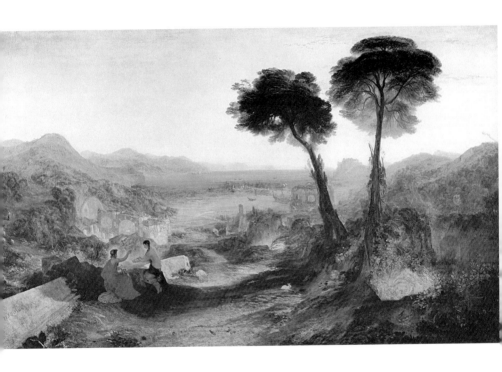

133

Also in 1811 he developed a new appreciation of the expressive power of black-and-white line-engraved reproduction of his works. (In this process an original image such as a painting or drawing is reproduced through its design being etched and cut into a metal plate; the colouristic and tonal qualities of the original are projected monochromatically by means of varying thicknesses and concentrations of line.) Turner had made watercolours to be copied as line-engravings ever since the early 1790s but in 1811 he was astounded by the degree of tonal beauty and expressiveness attained by one of his engravers, John Pye, in a print reproducing the oil painting *Pope's Villa at Twickenham*. Pye's success made Turner highly receptive to the notion of having more of his works reproduced in the same way.

Rye, Sussex

c. 1823
watercolour, 14.5 x 22.7 cm
National Museum of Wales, Cardiff

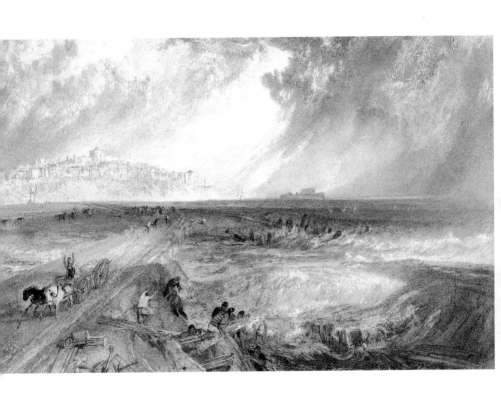

Obviously because word of this increased amenability quickly spread, not long afterwards the painter was commissioned by two other line-engravers and print publishers, the brothers William Bernard Cooke and George Cooke, to make a large set of watercolours depicting the scenery of the southern coast of England for subsequent line-engraving. The 'Picturesque Views on the Southern Coast' project was only completed in the mid-1820s and it led Turner to deploy enormous ingenuity in expressing the essentials of place, those underlying social, cultural, historical and economic factors that had once governed life there or continued to do so. (For an example of a 'Southern Coast' series watercolour, see *Rye, Sussex* of around 1823.)

A Storm (Shipwreck)

1823
watercolour, 43.4 x 63.2 cm
British Museum, London

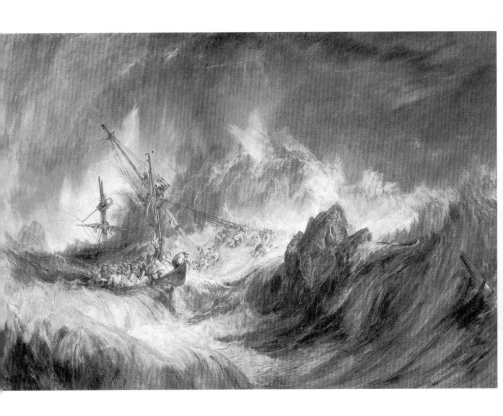

In time Turner would create several hundreds of watercolours for similar schemes, and in a large number of them he would similarly elaborate the truths of place with profound inventiveness. In 1812 Turner exhibited an unusually important picture at the Royal Academy, *Snow Storm: Hannibal and his Army crossing the Alps.* The subject had intrigued the painter ever since the late 1790s when he had copied a representation of Hannibal looking down into Italy by J.R. Cozens, a work that is unfortunately now lost. Yet the immediate inspiration for a painting on that subject only came to Turner late in the summer of 1810 when he was staying at Farnley Hall. One day he was witnessed by Fawkes's son, Hawksworth Fawkes, standing at the doorway of the house and looking out over Wharfedale; as the latter recalled, Turner shouted:

Roslin Castle

1823
watercolour, 17.5 x 26.5 cm
Indianopolis Museum of Art

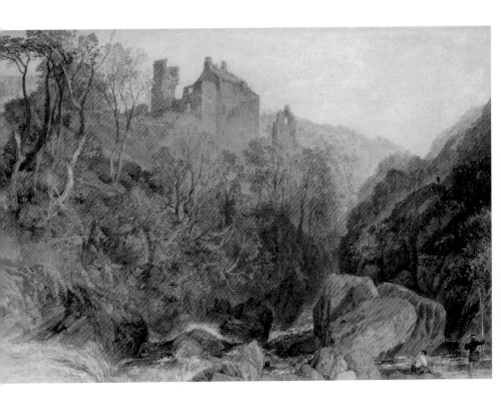

'Hawkey! Hawkey! Come here! come here! Look at this thunder-storm. Isn't it grand? – isn't it wonderful? – isn't it sublime?' All this time he was making notes of its form and colour on the back of a letter. I proposed some better drawing-block, but he said it did very well. He was absorbed – he was entranced. There was the storm rolling and sweeping and shafting out its lightning over the Yorkshire hills. Presently the storm passed, and he finished. 'There! Hawkey,' said he. 'In two years you will see this again, and call it "Hannibal Crossing the Alps".'

This story vividly indicates not only the force of Turner's inner eye but also his precise aesthetic leanings, for his immediate placing of a sublime natural effect at the service of an epic historical subject is profoundly poetical – clearly the

Grenoble Bridge

1824
watercolour and gouache, 53 x 73.7 cm
The Baltimore Museum of Art, Maryland

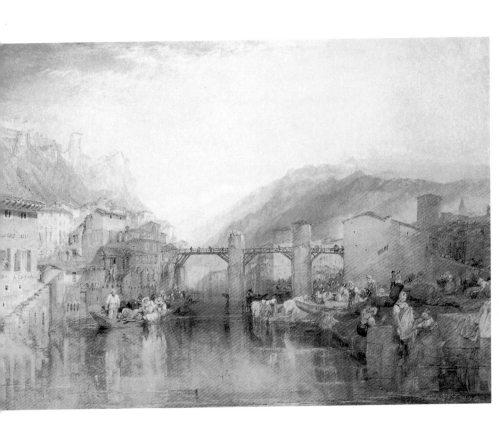

vastness of nature was not an end in itself for Turner, but merely a starting point. And the artist's adherence to the Theory of Poetic Painting is further proven by the method he employed to develop *Hannibal and his Army crossing the Alps*, for he synthesized the image exactly in the manner that Reynolds had recommended, in this case by marrying the Yorkshire storm to a Swiss alpine vista seen in 1802.

Turner equally made a helpful verbal debut with *Hannibal and his Army crossing the Alps*. Although the painter had been appending lines of verse to the titles of his pictures in the exhibition catalogues since 1798, and some of them were probably of his own devising, in 1812 and for the very first time he added lines that were openly by himself. These verses were drawn from a 'manuscript poem' entitled 'Fallacies of

Prudhoe Castle, Northumberland

c. 1825
watercolour, 29.2 x 40.8 cm
British Museum, London

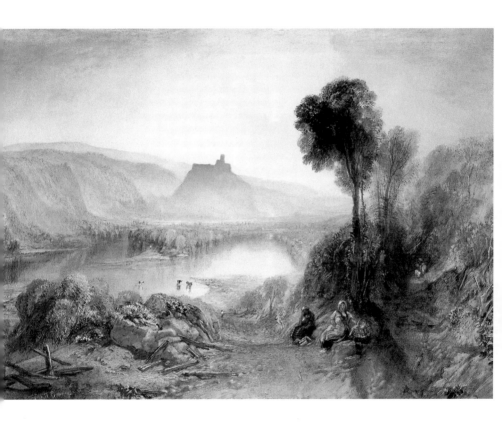

Hope' that only ever seems to have existed as short extracts in many of the Exhibition catalogues published between 1812 and 1850, the last year Turner exhibited at the Academy. Yet the title of this supposedly epic poem, and often the verses themselves, indicate the artist's general view that all hopes of successfully defying the forces of external nature, of overcoming the inherent weaknesses and contradictions of human nature, and of religious redemption, are fallacious. In the particular case of *Hannibal* the verse reminds us of the central irony of the Carthaginian general's life, that for all his immensely successful effort to cross the Alps into Italy, eventually he would entirely nullify his achievement by allowing his own strength and that of his countrymen to become weakened by a life of idleness and luxury at Capua. As a

Venice: the Grand Canal
Looking Towards the Dogana

c. 1840
watercolour, 22.1 x 32 cm
British Museum, London

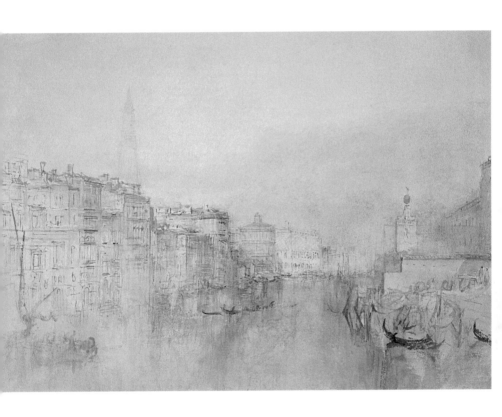

result, the Carthaginians would fritter away their chances of ever defeating the Romans.

Clearly this irony was directed at Turner's empire-building countrymen, warning of the perils that awaited them if they similarly put their own selfish interests above those of the state. At a time when Britain was still at war with Napoleon, this was a highly relevant message. The idea that the citizens of a given nation should eschew self-interest, vanity and luxury in pursuit of the common good was frequently encountered in eighteenth-century Augustan poetry, from whence Turner undoubtedly derived it. He was to repeat that old-fashioned message repeatedly after 1812 in many increasingly innovative images. These not only represent Carthage but also further great empires such as Greece, Rome and Venice, whose downfall

Portsmouth

c. 1825
watercolour, 16 x 24 cm
Turner Bequest, Tate Britain, London

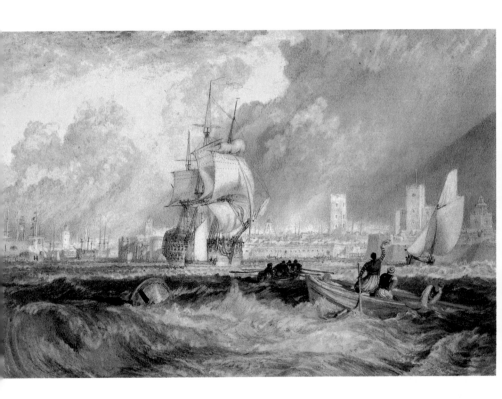

because of individual self-interest might similarly serve as warnings to England. Such political moralism externalised Turner's belief, stated in a letter of 1811, that it is the duty of a poet – and therefore by implication a poetic painter as well – to act as a moral seer.

The 1812 *Snow Storm: Hannibal and his Army crossing the Alps* received some very favourable comments. For example, the American painter Washington Allston called it a 'wonderfully fine thing', declaring that Turner was 'the greatest painter since the days of Claude'. Yet Turner's art was not always received so rapturously. Throughout the 1800s it had been severely criticized by the influential connoisseur, collector and artist Sir George Beaumont, who professed to be alarmed both by the liberties Turner took with appearances, and by the

Forum Romanum, for Mr Soane's Museum

RA 1826
oil on canvas, 145.5 x 237.5 cm
Turner Bequest, Tate Britain, London

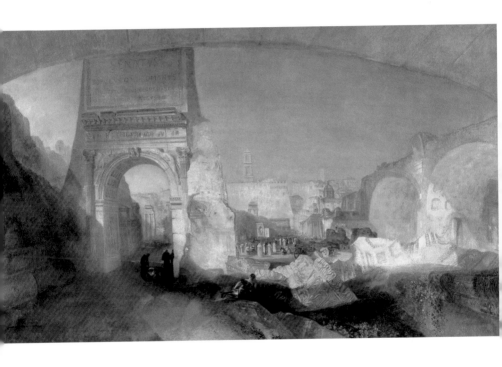

increasingly bright tonalities he employed. Probably Beaumont was secretly jealous of Turner's great artistic success, having once himself been called the 'head of the landscape [school]', a mantle that Turner had easily assumed during the 1790s and 1800s. Because of his distaste for Turner's pictures, Beaumont did his utmost to discourage other collectors from buying them. Turner was understandably infuriated by this, although by the early 1810s he already enjoyed a loyal following that was prepared to pay high prices for his works.

In the 1813 Royal Academy Exhibition Turner displayed an unusually fine rural scene, *Frosty Morning* (Tate Britain), which for once gives us not a grand statement but a small slice of everyday life (unfortunately the painting has now lost the glazes used to convey the hoariness of the frost). Also on show

The Seat of William Moffatt Esq.
at Mortlake, Early (Summer's) Morning

RA 1826
oil on canvas, 93 x 123.2 cm
The Frick Collection, New York

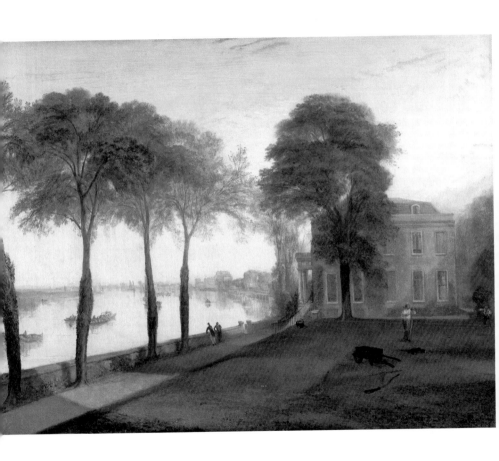

151

was a picture first exhibited in Turner's own gallery in 1805, a dramatic riposte to Poussin's *Deluge*. In 1814 the artist exhibited two works, one of which, *Apullia in search of Appullus* (Tate Britain), contained a veiled attack on Sir George Beaumont. And in 1815 Turner displayed two of his greatest paintings to date, *Crossing the Brook* and *Dido building Carthage; or the Rise of the Carthaginian Empire*. Turner called *Dido building Carthage* his 'chef d'oeuvre', and when he came to draw up the first version of his will in 1829 he requested that the canvas should be used as his winding-sheet upon his death. He even asked one of his executors, Francis Chantrey, as to whether that condition of the will would be carried out. To his eternal credit Chantrey replied that the stipulation would be respected but immediately added that 'as soon as you are

Mortlake Terrace, the Seat of William Moffatt,
Esq. Summer's Evening

RA 1827
oil on canvas, 92 x 122 cm
National Gallery of Art, Washington, D.C

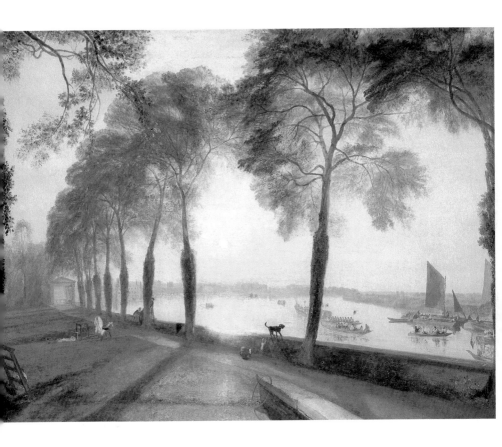

153

buried I will see you taken up and [the canvas] unrolled'. Turner saw the funny side of the situation and thereupon amended his will to bequeath the painting to the National Gallery to hang alongside the very seaport view by Claude that had moved him to tears when it was in the Angerstein collection.

It is not surprising that Turner particularly esteemed *Dido building Carthage*. He had long wanted to paint a seaport scene worthy of comparison with Claude, and with the painting he succeeded (just as in *Crossing the Brook* he painted his most successful Claudian landscape to date). Yet *Dido* also probably summarized everything he was trying so hard and so opaquely to articulate in the perspective lectures. With its mastery of perspective, its superb exploration of light, shade and

The Artist and His Admirers

c. 1827
watercolour on blue paper, 14 x 19 cm
Turner Bequest, Tate Britain, London

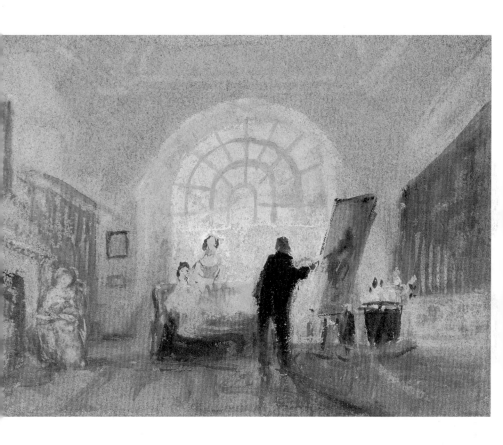

reflections, its moral contrast between life and death (as represented respectively by the teeming city and solemn tomb), and its total congruence of time of day, meaning and pictorial structure, it is certainly far more eloquent than any of Turner's tortuous verbal discourses.

Two years later Turner exhibited the companion to *Dido building Carthage*, namely *The Decline of the Carthaginian Empire*. In the intervening 1816 Royal Academy show he displayed two complementary pictures of a Greek temple. In one of them (Duke of Northumberland collection) he portrayed the building as it appeared in a ruined state under contemporary Turkish domination, while in the other he depicted it as it had probably looked in ancient times. The ruined building is appropriately represented in evening light,

Yarmouth

———

1827
watercolour, 27.9 x 39.4 cm
private collection

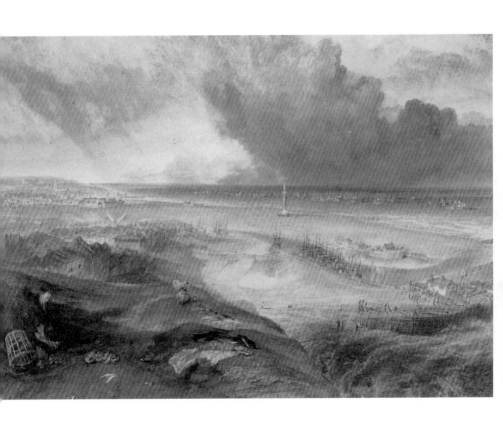

157

for metaphorically its day has passed. In the painting the artist showed the reconstructed building in dawn light, thus using the rebirth of day not only to suggest constant renewal within the ancient world but equally to hint at the future restoration of Greek liberty. This latter subject was immensely important to him, for he wholly shared the views of one of his favourite Augustan poets, James Thomson, that Greece was the ancient home of liberty and democracy. In 1812 Turner had been forcibly reminded of the subjugation of contemporary Greece by the publication of the second Canto of Byron's poem, 'Childe Harold's Pilgrimage', in which the loss of Greek liberty is lamented. The two 1816 paintings might therefore well have been their creator's most open statements of his identification with liberty and democracy to date.

Scene on the Loire
(near the Coteaux de Mauves)

c. 1828-30
watercolour and gouache with pencil on blue paper
14 x 19 cm
Ashmolean Museum, Oxford
This work was made for engraved reproduction
in Turner's Annual Tour – the Loire, 1833

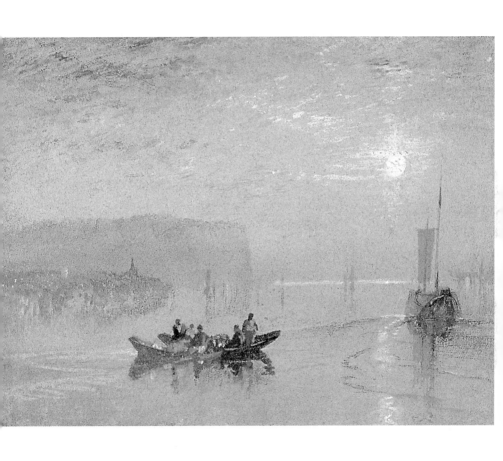

Turner lived through the greatest period of political upheaval in European history. His affinity with demands for political and religious freedom in his own time first seems to have found expression around 1800 in works alluding to contemporary struggles for liberty in Britain and abroad. During this period he was hoping to gain election as an Academician, and many of the leading Royal Academicians, such as Barry, Fuseli and Smirke, were known to hold libertarian opinions. By painting such pictures he may have been simultaneously courting their votes. Around that time Turner's most sympathetic future patron, Walter Fawkes, even held republican convictions, although he later moderated his stance (at least publicly). There can be absolutely no doubt that the similarity of their political views strengthened the bond

Petworth Park, with Lord Egremont and His Dogs;
Sample Study

———————

c. 1828
oil on canvas, 64.5 x 145.5 cm
Turner Bequest, Tate Britain, London

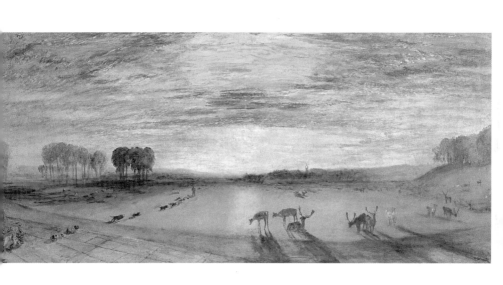

between Turner and Fawkes after 1808. Moreover, the painter is known to have read banned radical political literature in the early 1820s. He would continue subtly to express his libertarian views during the rest of that decade as the Greeks struggled for their freedom and demands for parliamentary reform in Britain quickened. In a number of works made between 1829 and 1833 Turner would even allude to the latter struggle, the major British political issue of his entire lifetime. In one such design – a watercolour representing a Parliamentary election in Northampton – he would even make his sympathies with the reform of Parliament quite clear, for the drawing shows the election of Lord Althorp, the Chancellor of the Exchequer in the reformist administration of Earl Grey. In several works made after the attainment of Greek independence in 1830,

Petworth Park

c. 1828-30
oil on canvas, 62 x 142 cm
Tate Britain and the National Trust
(Lord Egremont Collection), Petworth House

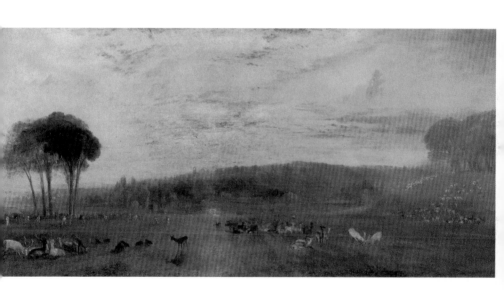

163

Turner would celebrate that rebirth of freedom (for example, see a watercolour of a fountain on the island of Chios). The artist's identification with libertarianism is entirely understandable, given his lowly origins and immense sympathies with common humanity. Although he always had to exercise extreme caution when expressing his political views – for the majority of his monied supporters held Tory political views, and were therefore opposed to parliamentary reform – Turner would never turn his back on either the social class from which he had emerged, or its political aspirations.

The painter resumed touring in the 1810s. In 1811, 1813 and 1814 he visited the West Country in order to obtain material for the 'Southern Coast' series and other engraving schemes. On the 1813 trip he had a particularly enjoyable

Kilgarren Castle, Pembrokeshire

────────────────────────────

1828
watercolour, 27.9 x 40 cm
private collection

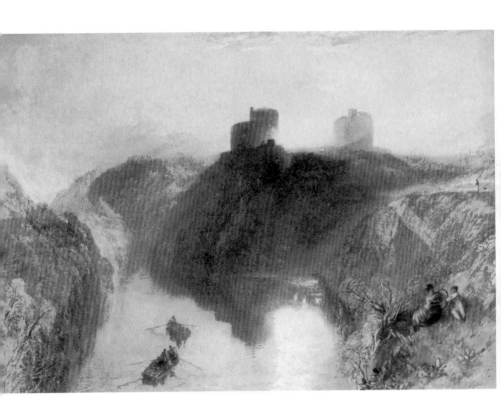

time in Plymouth where he was much fêted locally. He treated his friends to picnics, took boat rides in stormy weather – which he enjoyed enormously, having good sea-legs – and again painted in oils in the open air. In 1816 he undertook an extensive tour of the north of England to gather subjects for watercolours intended for engraved reproduction in the 'History of Richmondshire' scheme, a survey of a county that in medieval times had ranged from Richmond in Yorkshire to Lonsdale in Lancashire. He could not have selected a worse time for the trip, as a major volcanic eruption in the Pacific during the previous year was causing the acute disruption of world weather patterns, with endless rain in Britain (where it was called 'the year without a summer'). Originally Turner was to have made 120 watercolours for the project, and to have

Alnwick Castle, Northumberland

1828
watercolour, 28.3 x 48.3 cm
Art Gallery of South Australia, Adelaide

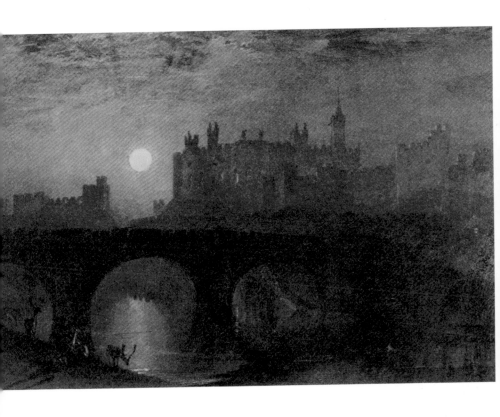

been paid the huge sum of 3000 guineas for those drawings. Unfortunately the venture petered out shortly after it had begun due to a lack of public enthusiasm for the antiquarian texts that accompanied Turner's images. By that time the artist had only made some twenty-one of the watercolours (*Crook of Lune, looking towards Hornby Castle*). In 1817 the painter revisited the Continent, stopping off at the scene of the recent battle of Waterloo before touring the Rhineland and visiting Holland where he scrutinised the Rembrandts in the Rijksmuseum in Amsterdam. Impressive paintings of Waterloo in the immediate aftermath of battle and of the river Maas at Dordrecht with shipping becalmed were exhibited at the Royal Academy the following year; not for the first time Turner used a pair of pictures to contrast war and peace.

West Cowes, Isle of Wight

1828
watercolour and gouache, 28.6 x 41.9 cm
private collection

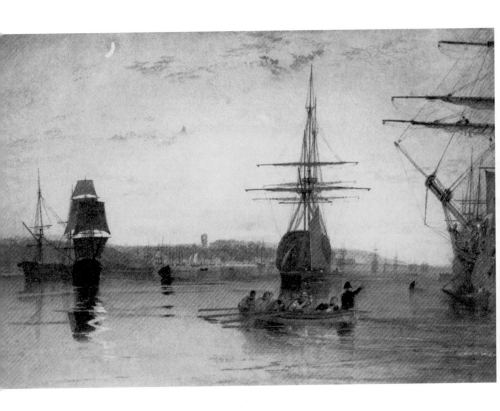

169

The Dordrecht view was purchased by Walter Fawkes who installed it over the fireplace at Farnley Hall as the centrepiece of his collection. Fawkes also bought a complete set of 50 watercolours on grey-washed paper that Turner had made in the Rhineland. And in 1819 Fawkes put a considerable part of his large collection of Turner watercolours on public display in his London residence. For the catalogue he wrote an impressive dedication to Turner, stating that he was never able to look at the artist's works 'without intensely feeling the delight I have experienced, during the greater part of my life, from the exercise of your talent and the pleasure of your society.' The dedication must have gratified the painter enormously.

Ulysses Deriding Polyphemus
- Homer's Odyssey

RA 1829
oil on canvas, 132.5 x 203 cm
Turner Bequest, National Gallery, London

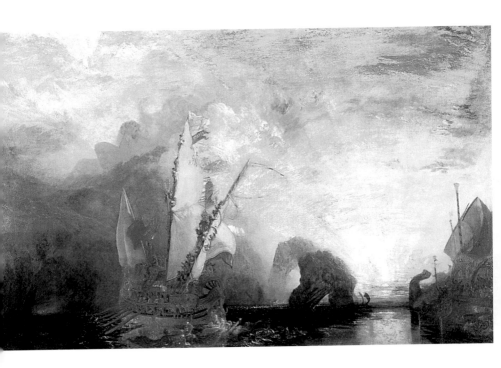

Turner finally visited Italy in 1819, although he had already developed a number of superb watercolours of Italian scenes from sketches made by others. He visited Milan, Venice, Rome, Naples, Sorrento and Paestum, before turning northwards and probably spending Christmas in Florence. His return journey took place in late January 1820, when he crossed the Mont Cenis pass, where his coach overturned during a snowstorm (wasting nothing, he later pictorialised the experience in a vivid watercolour now in Birmingham Art Gallery). He arrived back in London loaded down with some 2000 sketches and studies, and immediately started one of his largest paintings ever. This is a view from the loggia of the Vatican, showing the Renaissance painter Raphael in the foreground. It was displayed in the 1820 Royal Academy exhibition, obviously to

Messieurs les Voyageurs on Their Return from Italy (par la diligence) in a Snow Drift on Mount Tarrar – 22nd of January 1829

RA 1829
watercolour, 54.5 x 74.7 cm
British Museum, London

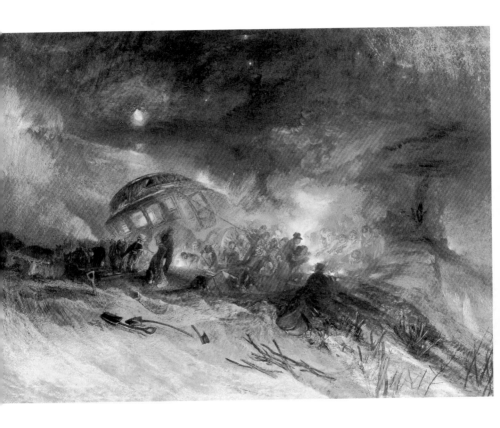

173

commemorate the Italian master who had died exactly three hundred years earlier.

Although Turner was increasingly busy making small watercolours for the engravers during the 1820s (such as the jewel-like drawing of *Portsmouth*), perhaps the most impressive watercolour achievements of the first half of the decade were the large and superbly wrought drawings made for the 'Marine Views' scheme. No less impressive are the oil paintings *The Bay of Baiae, with Apollo and the Sybil*, shown at the Academy in 1823, and *The Battle of Trafalgar* created between 1822 and 1824 to hang in St James's Palace. In *The Bay of Baiae* Turner again expressed his profound sense of irony, for the picture shows the god Apollo bestowing endless life upon the Cumaean Sibyl in exchange for her favours.

Northampton, Northamptonshire

1830-31
watercolour, 29.5 x 43.9 cm
private collection

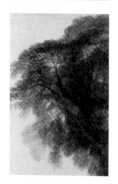

Unfortunately the poor lady forgets to request the eternal good looks necessary to accompany her longevity. The derelict buildings in the background hint at her forthcoming physical ruin, while the beauty of the surrounding landscape puts that decay into ironic perspective. It is not suprising that *The Battle of Trafalgar* is impressive, for it was the largest picture Turner would ever paint and fully captures the enormous forces unleashed by war.

Rise of the River Stour at Stourhead

1824
watercolour, 67.3 x 102.2 cm
The Sudeley Castle Trustees

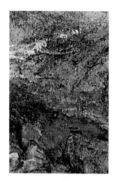

In 1825 Turner embarked upon yet another ambitious set of watercolours destined for engraved reproduction. This was the 'Picturesque Views in England and Wales' series, a group of drawings that has quite aptly been termed 'the central document of his art'. Like the 'Richmondshire' series, the 'England and Wales' scheme was to have comprised 120 designs, but this time the project floated long enough for the painter to create some 100 of the constituent images. Sadly the enterprise was terminated in 1838, due to the failure of the prints to sell and other factors that rendered their publication uneconomic. In 1829 Turner exhibited a fairly large group of 'England and Wales' watercolours in London, and he did so again in what must have been a dazzling show in 1833, when 67 drawings went on display. In the 'England and Wales'

Coriskin Lake

c. 1832
watercolour, 8.9 x 14.3 cm
National Gallery of Scotland, Edinburgh

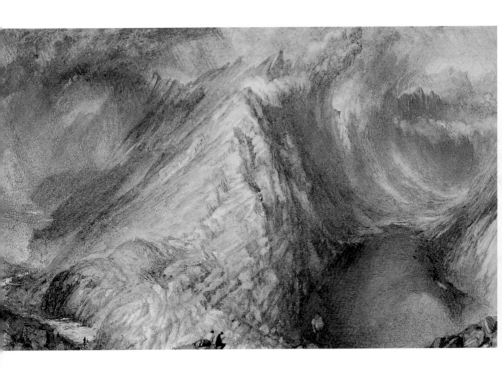

designs almost all aspects of British scenery and life are depicted, while Turner's unrivalled mastery of the medium of watercolour is everywhere apparent. And throughout the 1820s and '30s the painter was frantically busy producing marvellous watercolours for a host of other engraving projects as well. These included topographical surveys of the ports, rivers and east coast of England; explorations of the rivers of France (part of a scheme to survey the rivers of Europe that never got further than forays along the Seine and the Loire); and illustrations for books of the collected poetry of Sir Walter Scott, Lord Byron, Samuel Rogers and Thomas Campbell. Moreover, Turner also found the time to produce illustrations for Scott's collected prose works, and to depict the landscapes of the Bible. Although he had never visited the Holy Land, he

Scio (Fontana de Melek, Mehmet Pasha)

c. 1832
watercolour, 26 x 29 cm
private collection

elaborated these works from sketches made by travellers who had. Well might he have complained, as he had done in the mid-1820s, that there was 'no holiday ever for me'.

As we have seen, early on in his career Turner had of necessity evolved a production-line method for making his watercolours. Naturally, such a procedure proved of enormous benefit when creating large numbers of watercolours for engraving. Two accounts of the artist's watercolour technique have come down to us from the same witness:

There were four drawing boards, each of which had a handle screwed to the back. Turner, after sketching the subject in a fluent manner, grasped the handle and plunged the whole drawing into a pail of water by his side. Then quickly he washed in the principal hues that he required, flowing tint into

Mouth of the Seine, Quille-Boeuf

RA 1833
oil on canvas, 91.5 x 123.2 cm
Fundação Calouste Gulbenkian, Lisbon, Portugal

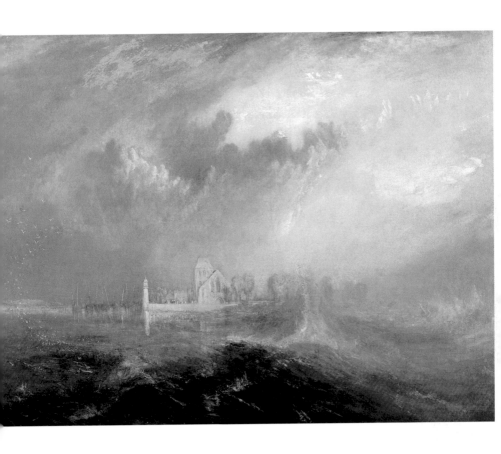

tint, until this stage of the work was complete. Leaving this drawing to dry, he took a second board and repeated the operation. By the time the fourth drawing was laid in, the first would be ready for the finishing touches.

...[Turner] stretched the paper on boards and after plunging them into water, he dropped the colours onto the paper while it was wet, making *marblings* and gradations throughout the work. His completing process was marvellously rapid, for he indicated his masses and incidents, took out half-lights, scraped out highlights and dragged, hatched and stippled until the design was finished. This swiftness, grounded on the scale practice in early life, enabled Turner to preserve the purity and luminosity of his work, and to paint at a prodigiously rapid rate.

Brinkburn Priory, Northumberland

1830
watercolour and gouache, 29.2 x 46.3 cm
Sheffield Galleries & Museums Trust

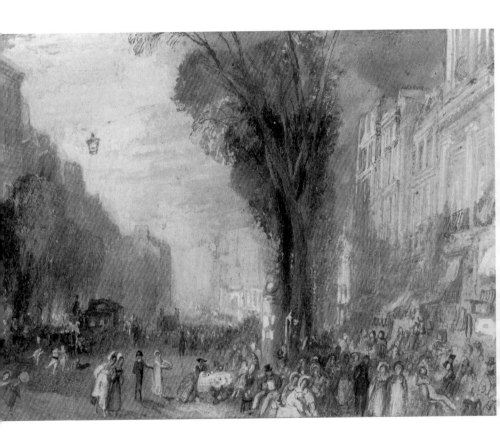

Judging by the results of such speedy and creatively economical working processes, the intense pressures put upon Turner by the engravers seems to have stimulated his inventive powers rather than hindered them.

In August 1828 Turner again travelled to Italy. He stayed principally in Rome where he both painted and exhibited those productions. The show attracted over 1000 visitors, most of whom were utterly mystified by what they saw. On his journey home in January 1829 his coach was again overturned by snow (as it had been some nine years earlier), this time on Mont de Tarare near Lyons in France. Again permitting no wastage, the artist recorded the experience in a watercolour exhibited in the 1829 Academy Exhibition. This time he put himself in the picture, wearing a top hat sitting in the foreground.

A Town on a River at Sunset

1833
watercolour and gouache, 13.4 x 18.9 cm
The Tate Gallery, London

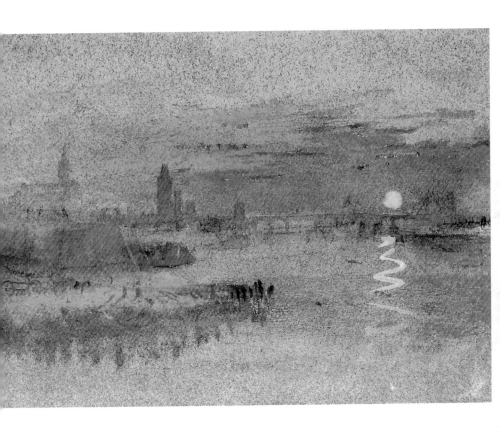

Another work that Turner displayed at the Academy in 1829 was *Ulysses deriding Polyphemus*. In connection with this oil, *The Times* commented that 'no other artist living... can exercise anything like the magic power which Turner wields with such ease.' John Ruskin later called *Ulysses* 'the *central picture* in Turner's career'. In colouristic terms at least, one can see why he did so, for by now the artist was achieving a beauty of colouring that was entirely commensurate with the 'Ideal Beauties' of form he had earlier mastered. This ideal colour derived from the fundamentals of painterly colour itself, for it was based upon the primaries of yellow, red and blue, with all kinds of wonderfully subtle modulations between them.

The Golden Bough

RA 1834
oil on canvas, 104 x 163.5 cm
Turner Bequest, Tate Britain, London

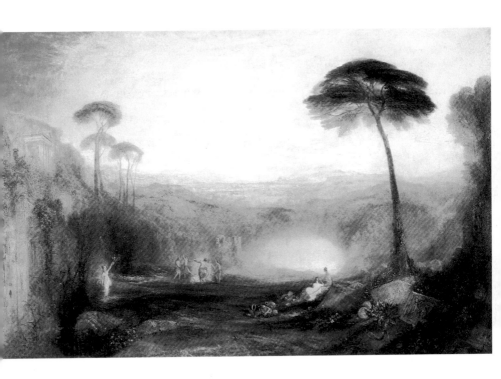

Naturally, Turner was always profoundly interested in colour theory, and that involvement was greatly stimulated by his investigation of the science of optics undertaken in connection with the perspective lectures. In 1818 he had introduced the subject of colour into those talks that were ostensibly about spatial and pictorial organization. A subtle change took place in Turner's colour around that time. Thereafter a greater reliance upon the primaries and a more intense luminosity became apparent in his work. And Turner's sense of the vivacity of colour was enormously stimulated by his visit to Italy in 1819, which seems natural, given that the colour sensibilities of most northern European artists are transformed by their contact with Italian light and colour. Certainly a change in Turner's colour was recognized by 1823, when an encyclopedia

Valley of the Brook Kedron

1834
watercolour, 14 x 20.3 cm
private collection

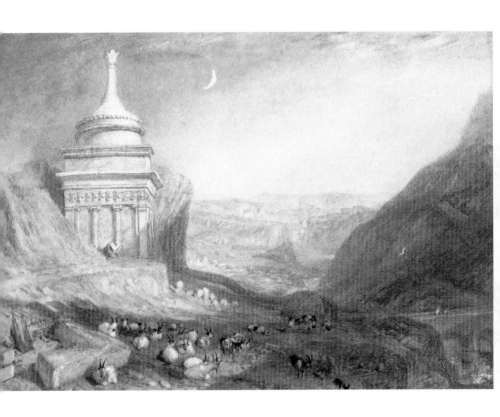

published in Edinburgh stated that Turner's 'genius seems to tremble on the verge of some new discovery in colour'. By the end of the 1820s, when *Ulysses deriding Polyphemus* appeared, such a 'discovery' had been thoroughly consolidated, and Turner began habitually creating ranges of colour that have never been matched by any other painter, let alone surpassed.

In October 1825 Walter Fawkes died. Turner subsequently refused ever to visit Farnley Hall again; it held too many memories for him. Clearly he was shattered by Fawkes's death, and he had good reason to be, for he was only six years younger than the Yorkshireman. Early in 1827 Turner wrote to a friend:

Temple of Minerva Sunias, Cape Colonna

1834
pencil and watercolour, 37.5 x 58.4 cm
The Tate Gallery, London

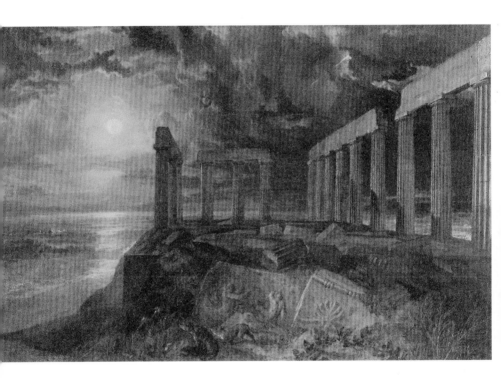

'Alas! my good Auld lang sine is gone ... and I must follow; indeed, I feel as you say, near a million times the brink of eternity, with me daddy only steps in between as it were...'

In September 1829 that brink moved appreciably closer when William Turner died, leaving the painter utterly bereft; as a friend remarked, 'Turner never appeared the same man after his father's death; his family was broken up.' The two men had always been especially close, doubtless because of the illness of Mary Turner. William Turner had served for many years as his son's factotum, stretching his canvases and varnishing them when completed, which led Turner to joke that his father both started and finished his pictures for him.

The Burning of the Houses of Parliament

B.I. 1835
oil on canvas, 92 x 123 cm
The Philadelphia Museum of Art, Philadelphia, Pennsylvania

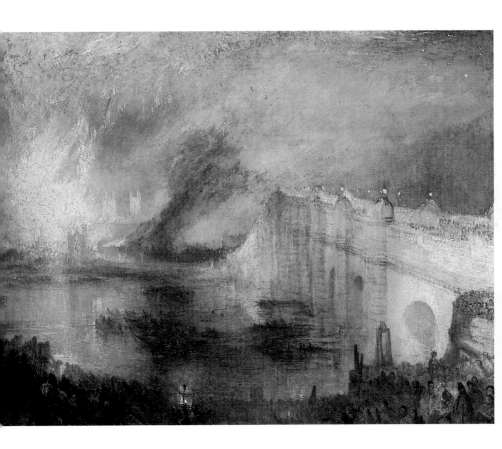

That the artist did feel nearer 'the brink of eternity' after his father's death is made clear by the fact that he drew up the first draft of his will less than ten days after the paternal demise.

The deaths of Fawkes and Turner's father were joined by other sad losses around this time, most notably those of Henry Fuseli in 1825 and of Sir Thomas Lawrence PRA early in 1830. Turner portrayed Lawrence's funeral in an impressive watercolour he exhibited at the Royal Academy later that year. This would be the last drawing he would ever display there, for works on paper were generally hung in inferior viewing conditions at the Academy and by this time Turner could show his watercolours more advantageously elsewhere (as he had done in 1829 and would again do in 1833). And because the artist refused ever to visit Farnley again, after 1827 he

Venice, from the Porch
of Madonna Della Salute

RA 1835
oil on canvas, 91.4 x 122 cm
Metropolitan Museum of Art, New York

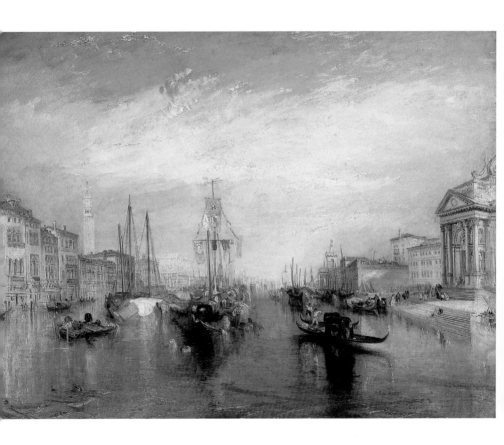

197

frequently took to staying at another 'home from home' owned by one of his patrons, namely Petworth House in Sussex. This was the country seat of George Wyndham, the 3rd Earl of Egremont, who was a collector of enormous taste and vigour. He had bought his first painting from Turner early in the century, and by the time of his death in 1837 he owned nineteen of his oils. At Petworth Turner was free to come and go at his leisure, although the age difference between the artist and his patron – the earl was seventy-six when the fifty-two-year-old painter began regularly revisiting the house in 1827 – meant that Turner could never be as close to the aristocrat as he had been to Walter Fawkes. After the earl died in 1837, Turner would shun Petworth, just as he had earlier shunned Farnley Hall, and for the same reason: death slammed certain doors in his life.

Flint Castle, North Wales

c. 1835
watercolour, 26.5 x 39.1 cm
Private Collection, U.K

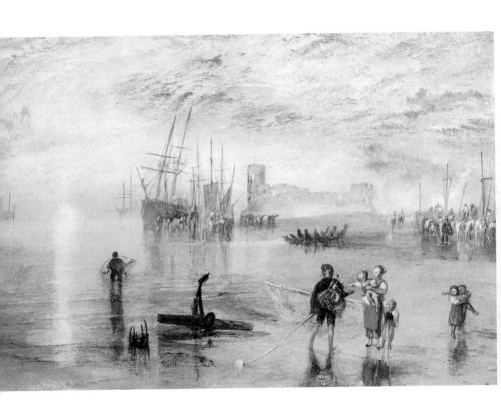

Turner came into conflict with John Constable RA (1776-1837) during the hanging of the 1831 Royal Academy Exhibition. The two painters had known each other since 1813 when Constable had sat next to Turner at an Academy dinner and was both entertained by his personality and impressed by his intellect. And Constable had a very high regard for Turner's works, praising their visionary qualities in 1828. But in 1831, when Constable was on the Academy hanging committee, he replaced Turner's painting of *Caligula's Palace and Bridge* (Tate Britain) with one of his own works, *Salisbury Cathedral from the Meadows* (National Gallery, London). The painter David Roberts RA (1796-1864) was present at a meeting of the two men soon afterwards, and he recorded what happened in his rather ungrammatical prose:

The Fighting 'Téméraire'
Tugged to Her Last Berth to be Broken Up, 1838

RA 1839
oil on canvas, 91 x 122 cm
Turner Bequest, Tate Britain, London

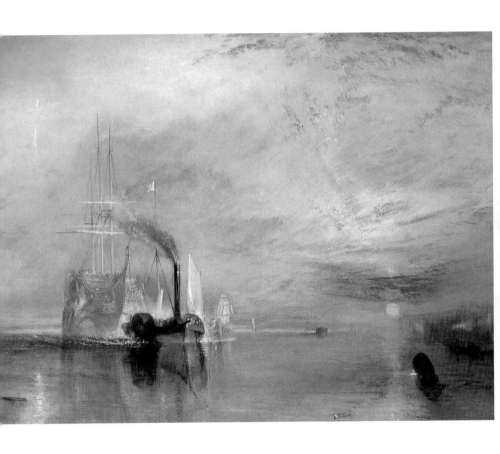

'Constable a conceited egotistic person... was loud in describing to all the severe duties he had undergone in the hanging of the Exhibition. According to his own account nothing could exceed his disinterestedness or his anxiety to discharge that Sacred Duty. Most unfortunately for him a Picture of Turners had been displaced after the arrangement of the room in which it was placed... Turner opened upon him like a ferret; it was evident to all present that Turner detested him; all present were puzzled what to do or say to stop this. Constable wriggled, twisted and made it appear or wished to make it appear that in his removal of the Picture he was only studying the best light or the best arrangement for Turner. The latter coming back invariably to the charge, yes, but why put your own there? – I must say that Constable looked to me and

Music

———

1835
oil on canvas, 121 x 90.5 cm
The Tate Gallery, London

I believe to every one else, like a detected criminal, and I must add Turner slew him without remorse. But as he had brought it upon himself few if any pitied him.'

However, Turner had his revenge in the Royal Academy the following year; as C.R. Leslie noted:

'In 1832, when Constable exhibited his *Opening of Waterloo Bridge* [Private Collection] it was placed in... one of the small rooms at Somerset House. A sea-piece, by Turner, was next to it – a grey picture, beautiful and true, but with no positive colour in any part of it [*Helvoetsluys;– the City of Utrecht, 64, going to Sea*, Tokyo, Fuji Museum]. Constable's *Waterloo* seemed as if painted with liquid gold and silver, and Turner came several times into the room while [Constable] was heightening with vermilion and laquer the decorations and

Scène in Val d'Aoste

c. 1836
watercolour, 23.7 x 29.8 cm
Fitzwilliam Museum, Cambridge

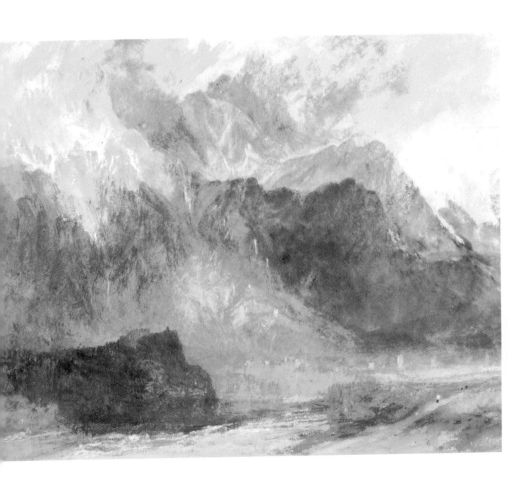

205

flags of the city barges. Turner stood behind him looking from the *Waterloo* to his own picture, and at last brought his palette from the great room where he was touching another picture, and putting a daub of red lead, somewhat bigger than a shilling, on his grey sea, went away without saying a word. The intensity of the red lead, made more vivid by the coolness of his picture, caused even the vermilion and laquer of Constable to look weak. I came into the room just as Turner left it. 'He has been here,' said Constable, 'and fired a gun.'...The great man did not come again into the room for a day and a half; and then, in the last moments that were allowed for painting, he glazed the scarlet seal he had put on his picture, and shaped it into a buoy.'

Snow Storm, Avalanche and Inundation
– a Scene in the Upper Part of Val d'Aouste, Piedmont

RA 1837
oil on canvas, 91.5 x 122.5 cm
Art Institute of Chicago, Illinois

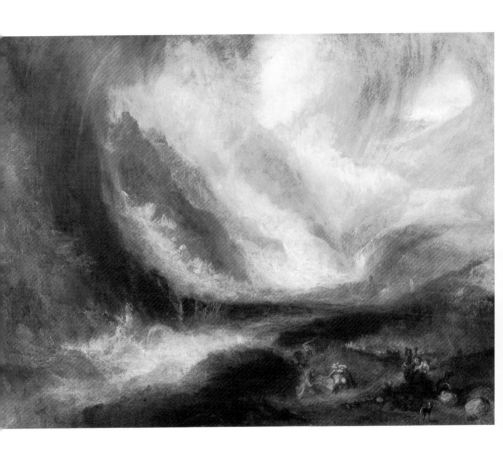

Turner greatly enjoyed playing these kinds of visual games on the Academy walls, where pictures were hung frame to frame. However, he did not always win such contests. His great friend, George Jones RA (1786-1869), recalled that in the 1833 Exhibition: *'The View of Venice with Canaletti painting* [by Turner, now Tate Britain] hung next to a picture of mine which had a very blue sky. [Turner] joked with me about it and threatened that if I did not alter it he would put it down by bright colour, which he was soon able to do by adding blue to his own... and then went to work on some other picture. I enjoyed the joke and resolved to imitate it, and introduced a great deal more white into my sky, which made his look much too blue. The ensuing day, he saw what I had done, laughed heartily, slapped my back and said I might enjoy the victory.'

Ancient Rome: Agrippina Landing
with the Ashes of Germanicus
The Triumphal Bridge and Palace of the Caesars
Restored

———

RA 1839
oil on canvas, 91.5 x 122 cm
Turner Bequest, Tate Britain, London

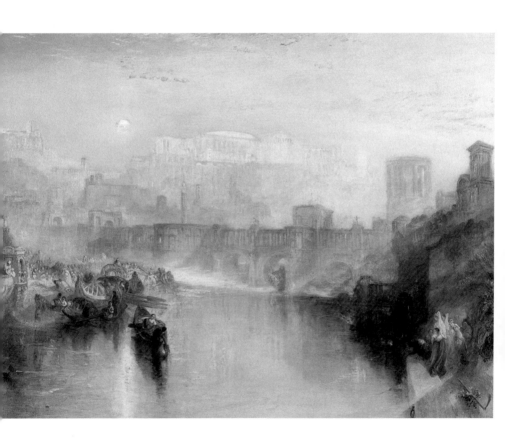

Turner also demonstrated his virtuosity in public during the 1830s, sending to Royal Academy and British Institution exhibitions rough underpaintings which he elaborated to a state of completion during the days permitted for varnishing pictures. Perhaps the most spectacular recorded instance of this practice occurred on the walls of the British Institution in 1835 when, in a single day, Turner painted almost the entirety of *The Burning of the Houses of Lords and Commons*. He had begun work at first light and painted all day, surrounded by a circle of admirers and without once stepping back to gauge the visual effect of his labours. Finally the picture was completed. As an eyewitness recorded:

Turner gathered his tools together, put them into and shut up the box, and then, with his face still turned to the wall, and at

Modern Italy: the Pifferari's

RA 1838
oil on canvas, 92.5 x 123 cm
Art Gallery and Museum, Glasgow

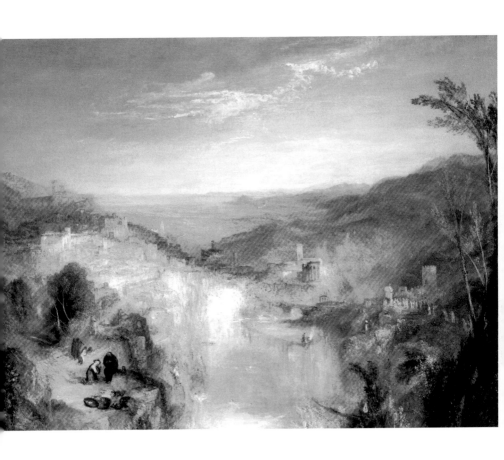

211

the same distance from it, went sidelong off, without speaking a word to anybody, and when he came to the staircase, in the centre of the room, hurried down as fast as he could. All looked with a half wondering smile, and Maclise, who stood near, remarked, 'There, that's masterly, he does not stop to look at his work; he *knows* it is done, and he is off.'

It has plausibly been suggested that Turner was led to demonstrate such virtuosic insouciance by having seen the violinist Paganini take London by storm with similar artistic equanimity in the early 1830s.

Turner continued to tour during the 1830s. An especially important trip took place in 1833. After exhibiting the view of Venice he had heightened with blue in competition with George Jones, Turner revisited the city, obviously to find out more about

Slavers Throwing Overboard the Dead and Dying
– Typhon Coming on

RA 1840
oil on canvas, 91 x 138 cm
Museum of Fine Arts, Boston, Massachusetts

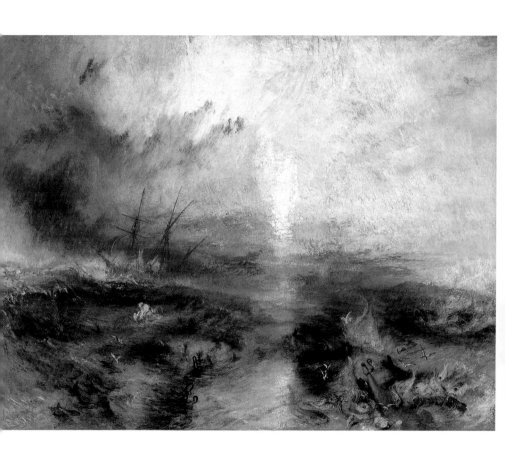

it (he had not stayed there long in 1819). From 1833 onwards the place would increasingly dominate Turner's Italian subject-matter, clearly because its frequently ethereal appearance struck a profoundly imaginative chord in him. He would return there in 1840. Another important peregrination took place in 1835, when Turner embarked on a grand tour of Europe. After sailing to Hamburg he then went on to Copenhagen, Berlin, Dresden, Prague, Nuremberg, Würzburg and Frankfurt-am-Main before travelling down the Rhine to Rotterdam. A secondary purpose of this tour may have been to examine some of the leading Continental museums and art collections in order to advise a government committee then drawing up plans for a combined National Gallery and Royal Academy building to stand on a site in Trafalgar Square.

Snow Storm – Steam-Boat off a Harbour's Mouth Making Signals in Shallow Water, and Going by the Lead

———

RA 1842
91.5 x 122 cm
The Author was in this storm on the night the Ariel left Harwich
Turner Bequest, Tate Britain, London

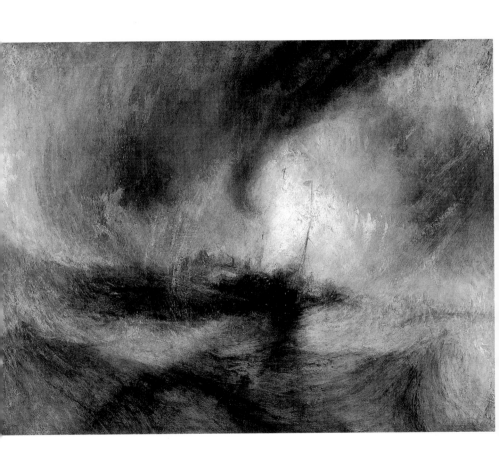

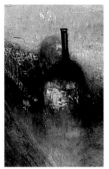

After 1833 a new companion entered the painter's life. Turner had continued to visit Margate down the years, and had latterly taken to staying with a Mrs Sophia Caroline Booth and her husband, who died in 1833. Slightly later the artist embarked upon a physical relationship with the widow, and eventually, in the 1840s, he moved her up to London to live with him in a cottage she purchased in Chelsea. David Roberts talked to her shortly after Turner's death in 1851, and later recorded (in his imperfect prose):

'...for about 18 years... they lived together as husband & wife, under the name of Mr & Mrs Booth... But the most extraordinary part of her narrative is that, with the exception of the 1st year he never contributed one shilling towards their mutual support! – But for 18 years she provided solely for their

Rain, Steam and Speed – the Great Western Railway

RA 1844
oil on canvas, 91 x 122 cm
Turner Bequest, National Gallery, London

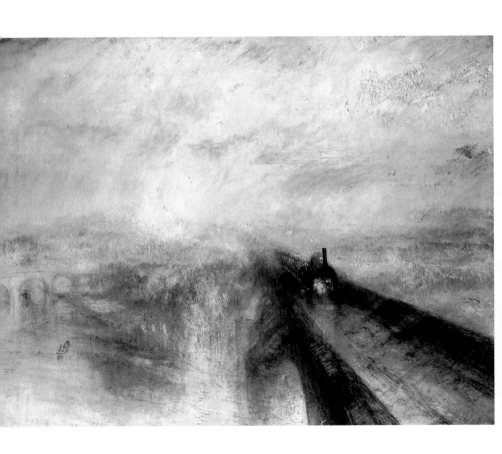

maintenance and living but purchased the cottage at Chelsea from money she had previously saved or inherited... Turner refusing to give a farthing towards it... She assures me that the only money she has belonging to him during this long term of years was three half crowns She found in his pocket after death, black, she says with being so long in his pocket & which she keeps as a souvenir...'

Turner had earned a reputation as a miser early on in life. Doubtless he had guarded every penny because in childhood he had often witnessed the destructive effects of poverty in the slum-infested Covent Garden area. Yet even when he became wealthy he maintained his penny-pinching habits. However, with the creation of his first will in 1829 a noble motive emerged from his habitual stinginess. Turner was well aware of

Venice: A Storm in the Piazzetta

c. 1840
watercolour, 21.9 x 32.1 cm
National Gallery of Scotland, Edinburgh, U.K

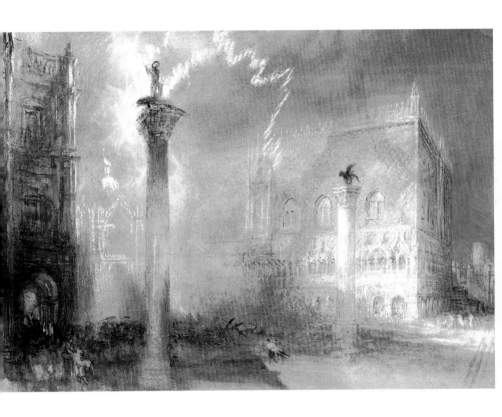

the precariousness of artistic fortune. That perception had led him to become one of the founders of the Artists' General Benevolent Institution upon its creation in 1814, as well as an early Chairman and Treasurer of the charity. Following disagreements over its spending policy – Turner was not happy disbursing money – he attempted to set up his own charitable foundation. This was to be funded by his estate and to be known as 'Turner's Gift'. It was designed to support old and penniless artists in almshouses to be built on land the painter also provided in Twickenham. Sadly, such a charity would never become a reality, as we shall see.

Throughout the 1830s and '40s Turner kept up a steady flow of masterpieces in both oil and watercolour. The public could not always read the images or fathom their meanings but that

View on a Cross-Canal near the Arsenal

1840
watercolour and gouache, 19.1 x 28 cm
The Tate Gallery, London

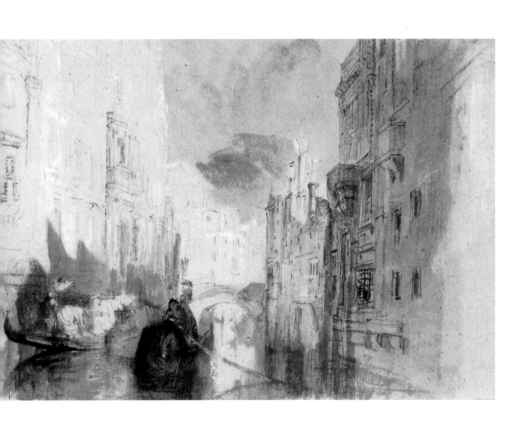

incomprehension did not lead the painter to make his depictions of things more visually approachable or simplify what he had to say – if anything the lack of understanding led him to make things even more difficult for his audience. Yet if pictures like the Venetian scene showing *Juliet and her nurse* of 1836 (Private Collection, Argentina) proved hard to understand – for why should Juliet be placed in a city she never visits in Shakespeare's play? – nonetheless the public had little if any difficulty in understanding an even finer masterpiece exhibited in 1839.

From the start *The Fighting 'Temeraire'* was interpreted as a wistful comment upon the passing of the age of Sail and the coming of the age of Steam. If we do indeed read it wholly in such terms it would be unusual, for more frequently the painter welcomed technological change. Thus, in the 1820s he had

The Lake of Geneva with the Dent d'Oche:
Tending the Vines

1841
watercolour, 22.8 x 29.1 cm
Turner Bequest, Tate Britain, London

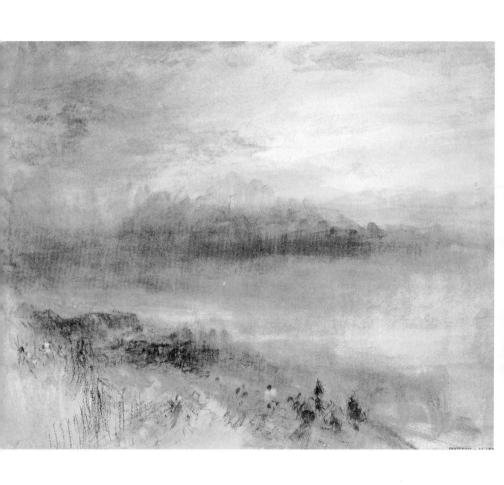

celebrated the advent of Steam in a view of Dover, while five years after painting *The Fighting 'Temeraire'* he would again make evident his excitement over the arrival of the modern industrial epoch in *Rain, Steam and Speed. The Great Western Railway* of 1844. During the 1840s the painter even became intrigued by polar exploration, yet another indication of his abiding interest in the opening up of the world around him. But in *The Fighting 'Temeraire'* Turner not only commemorated the passing of an age; he also welcomed the era that was supplanting it, for in the picture he subtly celebrated the physical power of steam.

The Blue Rigi: Lake Lucerne, Sunrise

1842
watercolour, 29.7 x 45 cm
Private Collection

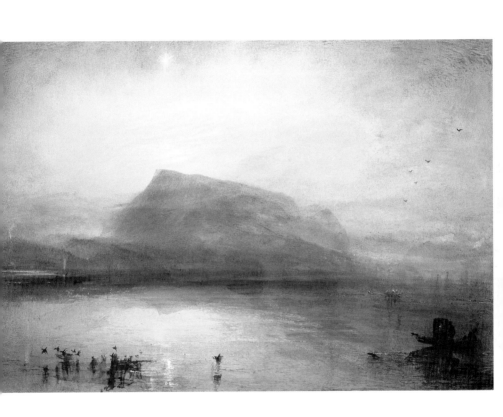

225

The favourable reception accorded to *The Fighting 'Temeraire'* must have been gratifying to Turner, especially as hostility to his works had been frequently voiced in newspaper reviews during the 1830s. The artist's 'indistinctness', his responsiveness to paint, his complex and often baffling meanings, and his increasingly high-keyed colour ranges (especially his love of yellow) were not calculated to win the hearts and minds of Victorians who preferred photographic realism to indistinctness, smoothness to painterliness, sentimentality to academic idealism, and saccharine colouring to the dazzling hues that Turner often presented to the eye. Yet from 1839, and particularly because of the vituperation poured on *Juliet and her nurse* in 1836 by one petty-minded critic, public understanding of what Turner was about was greatly

The Great Fall of the Reichenbach,
in the Valley of Hasle, Switzerland

1804
watercolour, 102.2 x 68.9 cm
Cecil Higgins Art Gallery, Bedford, U.K

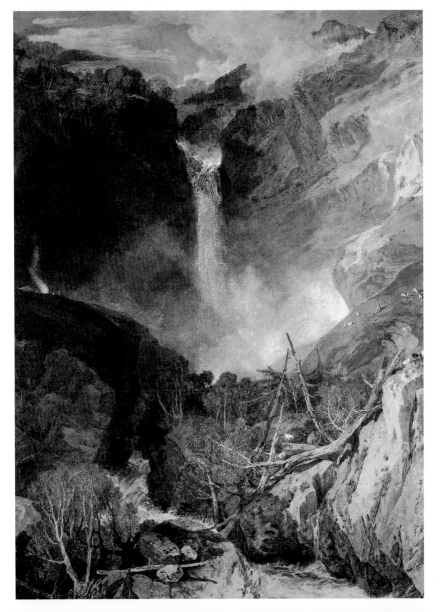

227

helped by a new supporter. This was John Ruskin, who between 1843 and 1860 published a five-volume appraisal of Turner's works entitled *Modern Painters*. In addition to matters already touched on, Ruskin's book was intended to demonstrate that 'We have had, living amongst us and working for us, the greatest painter of all time.' Turner was clearly not too displeased by Ruskin's advocacy, and indeed, it must have afforded him much comfort during the final years of his life.

The late 1830s and the 1840s were otherwise not an altogether happy time for Turner. He became bitter at having been passed over for a knighthood when lesser figures such as Augustus Wall Callcott RA (1779-1844) and William Allan RA (1782-1850) had been so honoured. (However, that lack of preferment was perhaps inevitable, given that Queen Victoria

Lake Lucerne:
The Bay of Uri from above Brunnen

———————————————————————

1842
watercolour, 29.8 x 45.7 cm
Private Collection, U.S.A

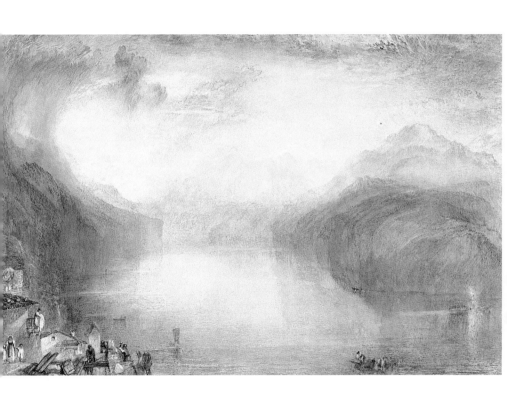

thought Turner to be quite mad.) And, as time passed, his despair at the thought of death increased. This resulted in somewhat unbalanced behaviour, such as becoming very secretive about his second home with Mrs Booth in Chelsea, where he was content to be known as 'Admiral Booth'. He also took to drink, albeit in a relatively mild way. An obsession with hoarding impressions of his prints led him to purchase all the remaining stock of the 'England and Wales' engravings when it was auctioned off in 1839, and then to let it rot in his house in Queen Anne Street West. Moreover, although by the late 1840s Turner had begun to form his wish that all his finished oil paintings should go to the National Gallery upon his death (a desire he formulated in final codicils to his will in 1848 and 1849), nonetheless he did little to ensure they were maintained

Peace – Burial at Sea

1842
oil on canvas, 87 x 86.5 cm
The Tate Gallery, London

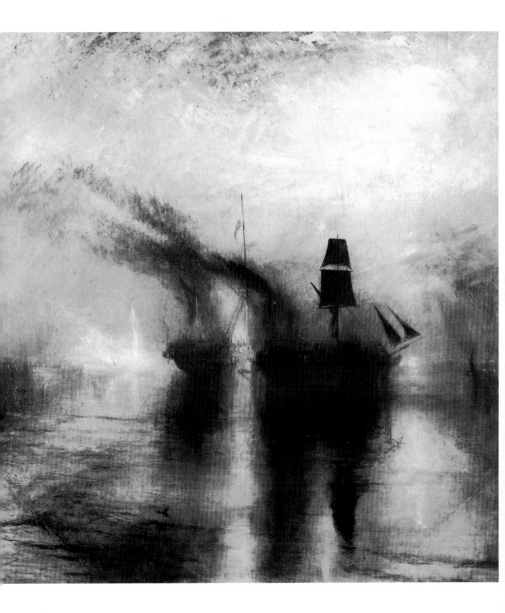

in good condition. Yet despite his fear of dying – an apprehensiveness that was unleavened by any belief in an afterlife – the artist did not let those anxieties and the eccentricities they produced darken his work. Instead, his late paintings and drawings became ever more beautiful as their creator used them to fend off his fears and bring the idealism of a lifetime to a triumphant conclusion.

In 1841, and during the following three summers, Turner returned to Switzerland. Four sets of watercolours resulted from those trips. They are among the painter's greatest creations, for in the immensity, beauty and solitude of the Alps he clearly found some solace at the thought of dying. In the final set especially, drawings that were possibly made between 1846 and 1850, we can apprehend a continuous pulse running

The Pass of Faido

1843
watercolour, 30.5 x 47 cm
Pierpont Morgan Library, New York

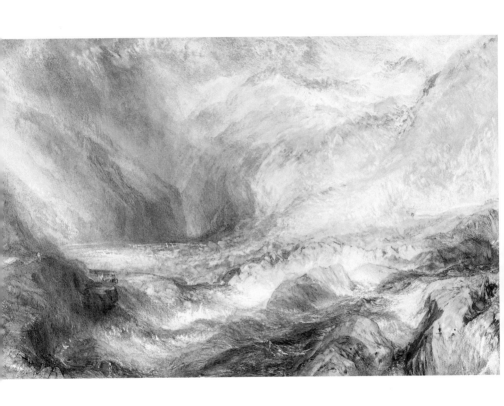

233

behind the appearances of discrete objects. As a result, the visible universe becomes filled with a primal energy. These characteristics are equally evident in a group of oil paintings made after about 1845 from the old *Liber Studiorum* images, works in which light, colour and energy are all intensified to the utmost degree, dissolving forms in the process. The 'Late Liber' paintings do not celebrate just the physical world: their pulsating energies, intensities of light and dissolutions of form are clearly expressions of something beyond the physical realm. Given Turner's lifelong attraction to academic idealism, at whose core lay a Platonic metaphysical system he had openly accepted at an early age, there can be no doubt that in his late, radiant images he was projecting a supernal reality, one corresponding to the world of the Ideas delineated by Plato. And there is no

Oberwesel

———

1840
watercolour and gouache, 34.5 x 53 cm
private collection

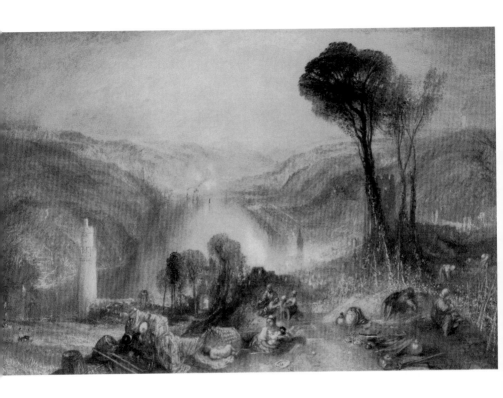

235

inconsistency between Turner's lifelong identification with such a metaphysical system and his supposed statement that 'The Sun is God', for the brilliant light in these late paintings is far more than simply the hedonistic sunshine that would later be so beloved of the French Impressionists. Instead, we are looking at Turner's deity, the essence and source of creation, the godhead itself, whose energies run through everything.

In 1845 the painter officially presided over the Royal Academy for a period when the elected President, Sir Martin Archer Shee (1769-1850), was too ill to carry out his duties. And also in that same year Turner made the last of his sketching tours, this time visiting northern France and calling upon King Louis Philippe, an old friend from Twickenham days. But Turner's health began to break down in 1845, and by the end of the following year it had become very bad indeed. It

Clyde's Falls

———————————

c. 1845
oil on canvas, 89 x 119.5 cm
Lady Lever Art Gallery, Port Sunlight

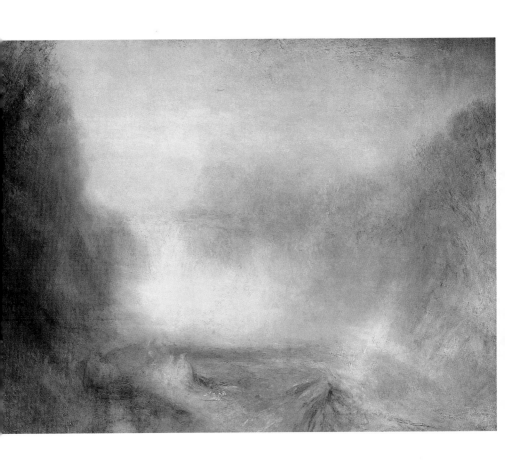

was not helped by the fact that he was losing all his teeth; in his final years he had to gain sustenance simply by sucking his food. He continued to show a few works every year at the Academy (although not in 1848, the first time since 1824 he had not exhibited), but gradually he began to lose the physical co-ordination necessary for painting. However, in 1850 he summoned forth his last vestiges of strength to complete four oil paintings on the Dido and Aeneas theme. The subject may have had a personal significance, for Turner's commitment to his art paralleled Aeneas's devotion to duty, an obligation that had led the Trojan prince to abandon Queen Dido in order to sail to Italy and found Rome. Like Aeneas, Turner had also forsworn an easy life, the enjoyment of wealth, marriage and the delights of the senses for a higher calling, while Queen Dido symbolised everything he had renounced.

Whalers

———

RA 1845
oil on canvas, 91.7 x 122.5 cm
The Metropolitan Museum, New York

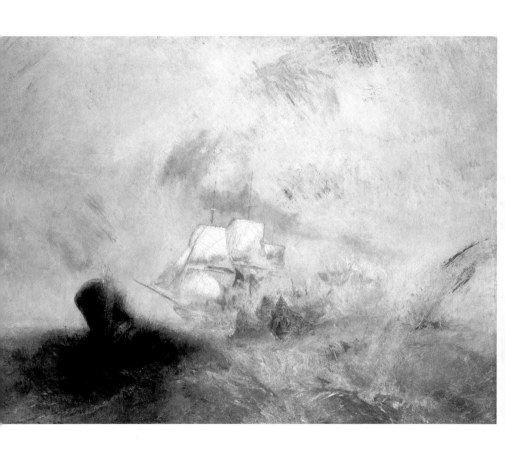

After displaying these last four works at the Royal Academy in the late spring of 1850 it appears that Turner was physically too feeble to paint any further. He awaited death over the following eighteen months rather apprehensively and sadly. Occasionally he would be helped onto the flat roof of the Chelsea house to see the sun rise over the level pastures of Battersea across the river – what he called the 'Dutch view' – or watch it set behind the hills upriver in the distance – his 'English view'. But that was all; the rest was silence.

Joseph Mallord William Turner died on 19 December 1851 and was buried in St Paul's Cathedral, almost next to Sir Joshua Reynolds, as he had requested. In addition to more than two thousand paintings and watercolours in private hands, he left an immense body of work in the Queen Anne Street West and Davis

Turner on Varnishing Day

William Parrot, c. 1846
oil on wood panel
University of Reading, Reading, U.K

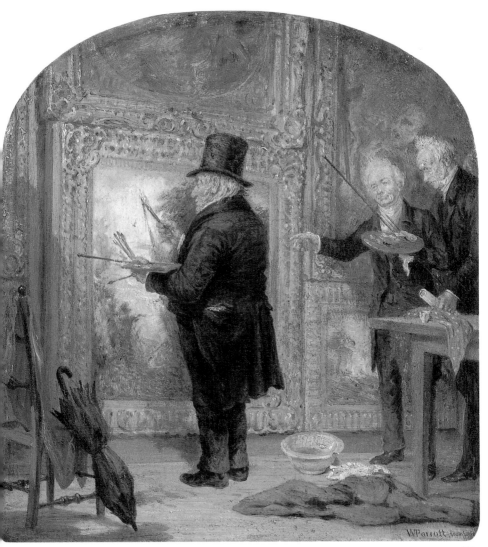

Place, Cremorne New Road, Chelsea studios – some 282 finished and unfinished oil paintings and 19,049 drawings and sketches in watercolour, pencil and other media (in addition to tens of thousands of prints, which were sold off in 1874). The estate was valued at £140,000, a sum whose exact modern value is incalculable but which might conservatively be approximated if we multiply it a hundredfold. The will contained two main provisions: that a gallery should be built to house Turner's works; and that 'Turner's Gift' should be created. However, the will was contested by Turner's relatives and unfortunately overthrown on a legal technicality. As a result, the relatives obtained the money and the charity was aborted. On the positive side the nation gained not only the finished oil paintings but all the unfinished oils as well, plus all the watercolours, sketchbooks, sketches and studies still gathering dust in the two studios.

The Lauerzersee, with the Mythens

c. 1848
watercolour, 33.7 x 54.5 cm
Victoria and Albert Museum, London

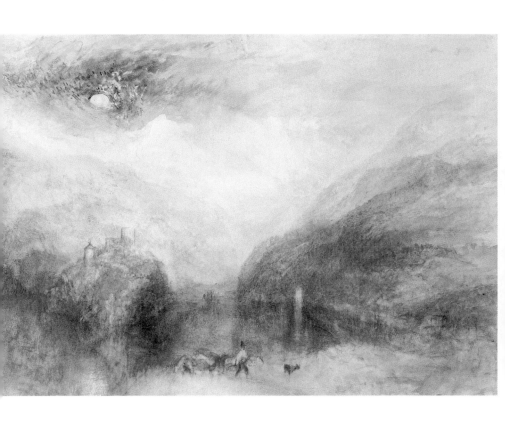

However, not until 1987 would a gallery be created specifically to house them. Only then would it come into existence through private largesse, and mainly because of pressure applied by an action group, the Turner Society.

The triumph of private greed over the realization of 'Turner's Gift' was brutally ironic, given that the painter had been so selfless in accruing wealth for the purpose of creating his charitable foundation. Eventually, of course, the Welfare State would take over the care of old, impoverished artists, so the failure of the charity to come into existence would not matter all that much. But ultimately Turner's supreme gifts were his bequest of works to the British nation, and his art in general. Both enormous legacies live on in a body of work that may have been equalled in size and quality, but which has never been surpassed for its beauty, power and insight. Turner's art

Yacht Approaching the Coast

c. 1850
oil on canvas, 102 x 142 cm
Turner Bequest, Tate Britain, London

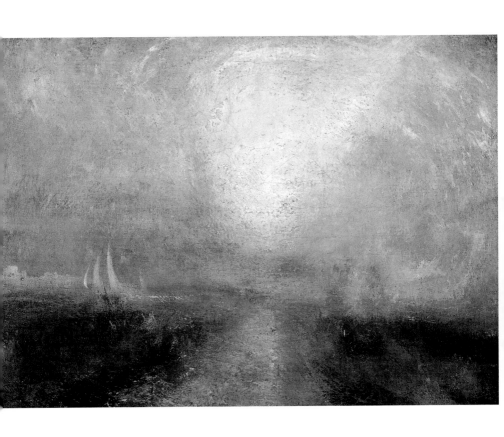

often takes us to the very heart of appearances and natural behaviour, and it was intended to forge all kinds of alliances with imaginative reality. But Turner was most decidedly not just a landscape and marine artist; equally he was a painter of mankind. As such he afforded us profound insights into the nature of the human condition, and the conditions in which we live. That he did so by means of a wholly innovative pictorial language should not blind us to the fact that his new visual direction in art was based upon extremely traditional aims. Turner stood on the very threshold of our present artistic epoch, for he was the last of the Old Masters and the first of the Moderns. Not until we see him in both of those roles together, and simultaneously appreciate his vast pictorial, intellectual and painterly complexity, will we then be in a true position to gauge the extraordinary scope of his genius, which still remains fully to be discovered.

The Departure of the Fleet
<hr>

RA 1850
oil on canvas, 91.5 x 122 cm
Turner Bequest, Tate Britain, London

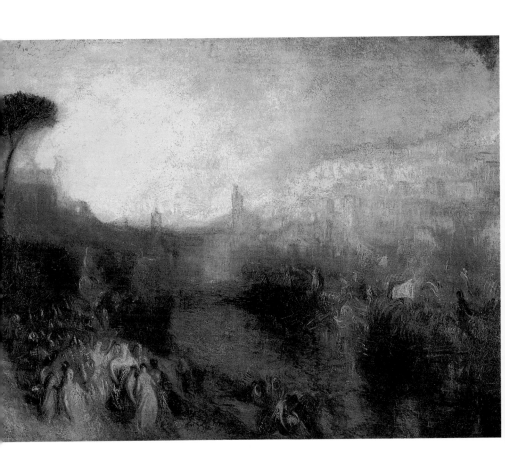

Index

A

A Storm (Shipwreck) 137

A Town on a River at Sunset 187

Abergavenny Bridge, Monmouthshire, Clearing up after a Showery Day 37

Alnwick Castle, Northumberland 167

Ancient Rome: Agrippina Landing with the Ashes of Germanicus.
The Triumphal Bridge and Palace of the Caesars Restored 209

B

Bolton Abbey, Yorkshire 69

Brinkburn Priory, Northumberland 185

C

Caernarvon Castle, North Wales 43

Calais Pier, with French Poissards Preparing for Sea: an English Packet Arriving 53

Caley Hall 109

Clyde's Falls 237

Colour Beginning 121

Constance 39

Coriskin Lake 179

Crook of Lune, Looking towards Hornby Castle 91

Crossing the Brook 83

D

Dido Building Carthage; or, the Rise of the Carthaginian Empire 81

Dolbadern Castle, North Wales 41

Dort, or Dordrecht, the Dort Packet-Boat from Rotterdam Becalmed 101

Dover Castle 129

Dutch Boats in a Gale: Fishermen Endeavouring to Put their Fish on Board

('The Bridgewater Seapiece') 47

E

England: Richmond Hill on the Prince Regent's Birthday 113

F

First-Rate, Taking in Stores 99

Fishermen at Sea 23

Flint Castle, North Wales 199

Folly Bridge and Bacon's Tower, Oxford 9

Forum Romanum, for Mr Soane's Museum 149

Frontispiece of 'Liber Studiorum', 77

G

Grenoble Bridge 141

H

Harewood House from the South-East 11

High Street, Oxford 55

I

Interior of King John's Palace, Eltham 15

Interior of Salisbury Cathedral, Looking Towards the North Transept 49

K

Kilgarren Castle, Pembrokeshire 165

L

Lake Lucerne: the Bay of Uri from above Brunnen 229

Llandaff Cathedral, South Wales 25

Loss of an East Indiaman 105

M

Marksburg 123

Marxbourg and Brugberg on the Rhine 95

Melrose Abbey 107

Mer de Glace, in the Valley of Chamouni, Switzerland 79

Messieurs les Voyageurs on their Return from Italy (par la diligence)

in a Snow Drift on Mount Tarrar – 22nd of January, 1829 173

Modern Italy: the Pifferari's 211

More Park, near Watford, on the Colne 127

Mortlake Terrace, the Seat of William Moffatt, Esq. Summer's Evening 153

Mosel Bridge at Coblenz 97

Mount Vesuvius in Eruption 93

Mouth of the Seine, Quille-Boeuf 183

Music 203

N

Norham Castle on the Tweed 85

Northampton, Northamptonshire 175

O

Oberwesel 235

P

Passage of Mont Cenis 125

Peace – Burial at Sea 231

Petworth Park 163

Petworth Park, with Lord Egremont and His Dogs; Sample Study 161

Pope's Villa at Twickenham 67

Portsmouth 147

Prudhoe Castle, Northumberland 143

R

Rain, Steam and Speed – the Great Western Railway 217

Richmond Hill 57

Rise of the River Stour at Stourhead 177

Rome, from the Vatican. Raffalle, Accompanied by La Fornarina
Preparing His Pictures for the Decoration of the Loggia 119

Roslin Castle 139

Rye, Sussex 135

S

Saint Giorgio Maggiore: Early Morning 117

Scène in Val d'Aoste 205

Scene on the Loire (near the Coteaux de Mauves) 159

Scio (Fontana de Melek, Mehmet Pasha) 181

Self-Portrait 31

Slavers Throwing Overboard the Dead and Dying – Typhon Coming on 213

Snow Storm – Steam-Boat off a Harbour's Mouth Making Signals in Shallow Water, and Going by the Lead 215

Snow storm, Avalanche and Inundation – a Scene in the Upper Part of Val d'Aouste, Piedmont 207

Snow Storm: Hannibal and His Army Crossing the Alps 75

South View from the Cloisters, Salisbury Cathedral 51

St Anselm's Chapel, with Part of Thomas-à-Becket's Crown Canterbury Cathedral 21

Sun Rising Through Vapour; Fisherman Cleaning and Selling Fish 65

Sunshine on the Tamar 45

T

Temple of Minerva Sunias, Cape Colonna 193

The Archbishop's Palace, Lambeth 13

The Artist and His Admirers 155

The Battle of Trafalgar 131

The Bay of Baiae: Apollo and the Sibyl 133

The Bell Rock Lighthouse 115

The Blue Rigi: Lake Lucerne, Sunrise 225

The Burning of the Houses of Parliament 195

The Decline of the Carthaginian Empire 89

The Departure of the Fleet 247

The Dormitory and Transcept of Fountain's Abbey – Evening 33

The Fall of an Avalanche in the Grisons 71

The Field of Waterloo 103

The Fighting 'Téméraire', Tugged to Her Last Berth to be Broken up, 1838 201

The Golden Bough 189

The Great Fall of the Reichenbach, in the Valley of Hasle, Switzerland 227

The Lake of Geneva with the Dent d'Oche: Tending the Vines 223

The Lauerzersee, with the Mythens 243

The Pantheon, the Morning after the Fire 17

The Pass of Faido 233

The Passage of Mount St Gothard, Taken from the Centre of the Teufels Broch

(Devil's Bridge), Switzerland 59

The Seat of William Moffatt Esq., at Mortlake, Early (Summer's) Morning 151

The Shipwreck 61

The Temple of Jupiter Panellenius Restored 87

The Thames near Walton Bridges 63

The Wreck of a Transport Ship 73

Tom Tower, Christ Church, Oxford 19

Trancept of Ewenny Priory, Glamorganshire 29

Turner on Varnishing Day 241

U

Ulysses Deriding Polyphemus – Homer's Odyssey 171

V

Valley of the Brook Kedron 191

Venice, from the Porch of Madonna Della Salute 197

Venice: A Storm in the Piazzetta 219

Venice: the Grand Canal Looking Towards the Dogana 145

View of Salisbury Cathedral from the Bishop's Garden 35

View on a Cross-Canal near the Arsenal 221

W

Weathercote Cave when Half filled With Water 111

West Cowes, Isle of Wight 169

Whalers 239

Wolverhampton, Staffordshire 27

Y

Yacht Approaching the Coast 245

Yarmouth 157